D0609263

Ways of Curating

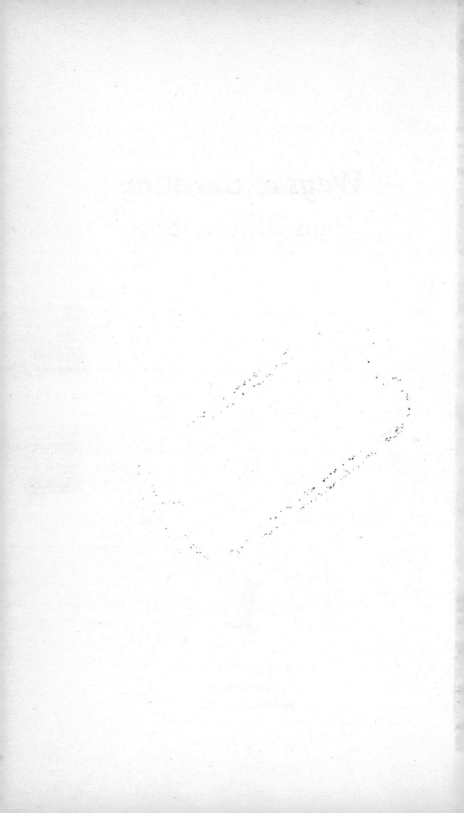

Ways of Curating
Hans Ulrich Obrist

with *Asad Raza*

ALLEN LANE
an imprint of
PENGUIN BOOKS

ALLEN LANE

Published by the Penguin Group

Penguin Books Ltd, 80 Strand, London WC2R ORL, England

Penguin Group (USA) Inc., 375 Hudson Street, New York, New York 10014, USA

Penguin Group (Canada), 90 Eglinton Avenue East, Suite 700, Toronto, Ontario, Canada M4P 2Y3
(a division of Pearson Penguin Canada Inc.)

Penguin Ireland, 25 St Stephen's Green, Dublin 2, Ireland (a division of Penguin Books Ltd)

Penguin Group (Australia), 707 Collins Street, Melbourne, Victoria 3008,
Australia (a division of Pearson Australia Group Pty Ltd)

Penguin Books India Pvt Ltd, 11 Community Centre,
Panchsheel Park, New Delhi – 110 017, India

Penguin Group (NZ), 67 Apollo Drive, Rosedale, Auckland 0632, New Zealand
(a division of Pearson New Zealand Ltd)

Penguin Books (South Africa) (Pty) Ltd, Block D, Rosebank Office Park,
181 Jan Smuts Avenue, Parktown North, Gauteng 2193, South Africa

Penguin Books Ltd, Registered Offices: 80 Strand, London WC2R ORL, England

www.penguin.com

First published 2014
001

Set in 12/15.5pt Dante MT Std
Typeset by Jouve (UK), Milton Keynes
Printed in Great Britain by Clays Ltd, St Ives plc

ISBN: 978-1-846-14401-1

www.greenpenguin.co.uk

This book is dedicated to the memory of David Weiss (1946–2012)

Contents

Prologue
The Way Things Go

Switzerland is a landlocked country. Without access to the sea, circumscribed by the Alps, the place is famously insular: there are hurdles between Switzerland and the nations that surround it. Yet it is also a crossroads, lying at the centre of a continent. Perhaps these simple facts explain, in part, the number of curators who come from there. Switzerland is both a polyglot culture that speaks the languages of the three countries which surround it, and a space apart that does not admit new influences without a process of selection. There is a fundamental similarity to the act of curating, which at its most basic is simply about connecting cultures, bringing their elements into proximity with each other – the task of curating is to make junctions, to allow different elements to touch. You might describe it as the attempted pollination of culture, or a form of map-making that opens new routes through a city, a people or a world.

On his departure from Switzerland in 1970, the writer Paul Nizon left, as his farewell, a book-length critique of what he called its 'discourse of narrowness': its conservatism, its lack of movement, its lack of metropolitan *bricolage*, or mixing. Nizon accused the country of a dangerous self-sufficiency. In Switzerland, according to Nizon, beauty was for the rich and luxury was hidden as a form of false modesty. This was his portrait of

the country where I was born in 1968. One might observe, however, that these conditions also create the impulse to overcome them, even for Nizon himself. Resources are so often generated by constraints, and unsatisfying conditions incite the imagination of new possibilities. Like Nizon, I eventually left the country in order to expand my sense of the world. Yet, when I look back at my early years in Switzerland, I find almost all the interests, themes and obsessions that have shaped my entire trajectory appeared very early in a series of encounters with places and people: museums, libraries, exhibitions, curators, poets, playwrights and, most importantly, artists.

In 1985, when I was sixteen, I saw Peter Fischli and David Weiss's exhibition at the Kunsthalle Basel, and it struck me deeply. A few weeks later, I came upon a copy of a book by the two artists called *Plötzlich diese Übersicht* (or *Suddenly This Overview*). It contained photographs of a series of hand-modelled, unfired clay sculptures, forming a series of highly varied and often dryly funny vignettes – a clay mouse and a clay elephant of the same size marked *Big* and *Small*, two forlorn figures in overcoats labelled *Strangers in the Night, Exchanging Glances*, a Japanese rock garden drolly transmuted into three lumps. The works depicted both the auspicious and deeply inauspicious moments of history in the same irreverent style. They showed an impulse to explore, map and collect human scenarios, with a combination of great scope and miniature scale. I looked at it daily. After some months, I found the courage to ring Fischli and Weiss at their studio in Zurich, and propose that I visit them. They said I was very welcome.

At the time, they were working on a project that was to become one of their most iconic, a film called *The Way Things Go*, in which a series of everyday objects and machine parts roll, topple, burn, spill or otherwise propel themselves forwards to

create an extended chain reaction of miraculous causes and effects. Allegorizing contingency and entropy just as much as they convey Fischli and Weiss's mischievous humour and amazingly creative experimentalism, these chemical and physical sequences create the illusion that the objects have mysteriously achieved independence from human control. *The Way Things Go* imparts a strong sense of the artists' pleasure in the process of art's production, in the taking-apart and putting-together of things, the precision of poise as well as the release of collapse.

At every transition in the film, the viewer is anxious about continuity, which is nevertheless maintained, even though at many points it seems impossible that the crucial energy transfer will occur. Hence, it always seems as if collapse and chaos are imminent, but, frequently, irregularities and exceptions are what prevent the system from coming to a standstill. The film is a journey during which banal objects tip the scales and move the action forward; it is also a journey without beginning or end, without a clearly defined goal. The events in the film cannot be localized, and the distances that have truly been covered cannot be determined. *The Way Things Go* is a journey from somewhere that leads us somewhere. The journey becomes, as Paul Virilio wrote, a waiting for an arrival that does not occur.

Around the time, Fischli and Weiss began another project, *Visible World*, which they would continue to work on for fourteen years. The work is a collection of 3,000 small-format photographs arranged and displayed on a specially constructed 90-foot-long light table. In it, elements of our collective visual world are drawn together into an immense collection of details of everyday life. The images are drawn from the four corners of the world, taking in an array of the manifold natural and

built environments – the places and non-places – within which contemporary existence is played out, ranging from jungles, gardens, deserts, mountains and beaches to cities, offices, apartments, airports, famous landmarks like the Eiffel Tower and Golden Gate Bridge, and everything in between. Everyone who comes to the work will find in it his or her world: a Buddhist will find Buddhism; a farmer will find agriculture; a frequent flyer will find aeroplanes. But, like the world itself, *Visible World* can never be seen in its entirety; it denies the total view.

The two artists always evinced a love of asking questions, often unanswerable. The same year I met them, they also created their *Question Pots*, which were large vessels displaying a range of questions. Nearly two decades later came *Questions*, a projected work displaying more than 1,000 existentially themed, handwritten questions, which they showed at the Venice Biennale in 2003. Their book of that year, *Will Happiness Find Me?*, featured small and big questions of all kinds, continually oscillating between banality and wisdom.

Restless, endlessly surprising and never seeking the limelight (they rarely granted interviews), Fischli and Weiss were the serial inventors of the art world. In photographs, films, sculptures, books and installations they documented everyday objects liberated from their everyday functions and placed in shifting relations to each other. Together the pair created some of the richest, most memorable and profoundly human work of the past three decades. Fredric Jameson once observed that our postmodern era is marked by a 'waning of affect', a loss of sincerity and authenticity and their wholesale replacement by irony. Yet Fischli and Weiss demonstrated that irony and sincerity could not exist without each other; that, indeed, there is no sincerity like irony.

4

My first visit to their studio became my eureka moment. I was born in the studio of Fischli and Weiss: that is where I decided I wanted to curate exhibitions, though I had been looking at artworks, collections and exhibitions for most of my adolescence. Fischli and Weiss, masters of questioning, were also the first to ask me what else I had seen, and what I thought of what I had seen, and so I began to develop a critical consciousness, a drive to explain and justify my reactions to art – to enter into a dialogue. Because of their work's extraordinary range, I also began to think much more globally. Through their work, Fischli and Weiss expanded my definition of art – and this is perhaps the best definition of art: that which expands the definition. Their friendship and the interest they took in me began a kind of chain reaction that has never stopped.

They also began to tell me about other artists whose work I should see, and whom I should meet. The month after my meeting with Fischli and Weiss, I visited the studio of the German artist Hans-Peter Feldmann. Feldmann's work uses common and overlooked media as the stuff of art, from the ephemera of daily life to albums of photographs, working these materials into enigmatic assemblages and series of objects that hover on the cusp between Conceptual art and Pop. Like much of the Conceptual tradition, these assemblages are serial and repetitive, and they recover and reuse detritus as subject matter. Repetition and difference are the guiding threads of his art, which finds its footing at the intersection of our society's incessant production and consumption, where novelty and obsolescence collide. He is also one of the key progenitors of the artist's book, establishing it as a recognizable form for artistic practice.

Many of Feldmann's projects involve collections of

photographs – which affected me as another example of an artist trying to produce a sense of comprehensiveness. For instance, a particularly characteristic work, Feldmann's 100 Years, presents a complete picture of human development in the shape of 101 black and white photographs. The images depict 101 different people, photographed by the artist from among his family, friends and acquaintances. The first shows an eight-month-old baby born in 1999; the second a child of one; the third, a child of two; and so forth. The work ends with an image of a 100-year-old woman. Feldmann's artistic activity reminds us that curiosity and collecting are basic animating impulses for everyone.

This brings us to the very first encounter I had with an artist. In my childhood in the countryside, the only large city was Zurich. I would go there once a month with my parents and I have strong memories from around age eleven of a man selling flowers and artworks in the city's luxurious shopping street, the Bahnhofstrasse. His name was Hans Krüsi. He was from St Gallen as well, but would go to Zurich on a regular basis, because he hadn't been discovered by other museums or galleries. He worked following an encyclopedic don't-stop principle, filling paper, canvas, notepads – whatever he could get hold of – in an endless drawing activity. Krüsi was orphaned very young and had mostly been alone. He grew up on a farm owned by his foster parents and then lived on the margins in St Gallen and elsewhere. He had some strange jobs and eventually started to commute to Zurich to sell flowers on the Bahnhofstrasse amidst banks and shops. In the mid-1970s he also started to sell postcard-sized pictures, which he painted with pastoral scenes and animal motifs. After his early exhibitions on the streets, Krüsi started to be discovered by galleries. As a teenager, I saw some of his exhibitions and wanted to find out more about the

artist's unusual practice. It was difficult to reach him, but I finally made a studio visit.

Visiting Krüsi was an extraordinary experience. His studio was filled with tens of thousands of drawings, sketches, stencils and motifs – mainly cows. There is a word in Swiss-German – *Alpaufzug* – which describes the ceremony when the cattle return to the Alps and go up into the hills for the summer pastures. Krüsi had painted many of these *Alpaufzug* scenes. He used house-paint, felt-tips and spray-paint for the larger scenes on paper and cardboard. Besides the cows, there were farmhouses, mountains and lots of cats, rabbits and birds – like a menagerie. Krüsi always had dozens of stencils with him which he would trace on pieces of paper. On them he described himself as a *Kunstmaler* (or artist-painter) and wrote the date and his address. Later on, he replaced his own address with the image of a cow – always adding the date, as if, like a letter, his artwork was merely that day's missive from his personal experience. A lot of conceptual artists, I came to realize, use stencils as a way of producing seriality, repetition and difference.

His obsessive drawing activity led to something he called the Cow Machines, which were and are an almost cinematographic, filmic representation of the *Alpaufzug*. Obviously it's never possible to do a synthetic image of the *Alpaufzug*, because it involves the gradual movement of hundreds of cows up a hill. So, at a certain moment, Krüsi decided simply to animate his drawings. He designed a box with two handles. Inside, he placed a scroll illustrated with painted cows. Krüsi would then turn the handles, which rotated the scroll – he would do demonstrations in the studio for hours and hours. It was like a cow marathon. Like much of his work, the cow machines were always about seriality – often depicting the same cow repeated with slight differences: for instance, a yellow cow with four

green legs, then the same image in an alternate colour scheme. Krusi's cow machines, of course, also demonstrated his connection to cinema. As the poet Czesław Miłosz later told me, twentieth-century poetry, literature and architecture have all been influenced by cinema. Krüsi himself always said that cinema and TV were a big influence on his work as a painter.

There was also a Warholian dimension to Krüsi, because he obsessively recorded everything. His studio was full of old cameras and obsolete recording devices. He would obsessively record birds and not only did he paint cows, but he recorded hundreds of hours of the sounds of cows. His work almost became an animal time capsule. I don't know what happened to all this sound documentation, which is now common in contemporary art. Krüsi also liked bells, because their sounds were a way of mapping the city – so he recorded all the bells in St Gallen. Going to his studio was like experiencing a work of art without any divisions. This wasn't someone who made drawings, then paintings, then sound, then architecture. In Krüsi's studio it all came together at once – all the senses, all the arts.

With Alighiero Boetti

In 1986, during a school trip to Rome, I decided to go my own way and visit someone whom Fischli and Weiss had told me was one of their heroes: Alighiero Boetti. At the time of my first visit, he was working on ideas relating to maps and map-making. Boetti had an epiphany about maps in 1971, and had then begun an extensive and labour-intensive project, making embroidered maps (*Mappa*) of the world. He collaborated with embroiderers in Afghanistan and later Pakistan to produce extraordinary map works, travelling to these countries on many occasions but also collaborating at a distance, especially following the Soviet occupation of Afghanistan in 1979. These collaborations intertwined aesthetic and political concerns, craftsmanship and the physical journey of the artist, as well as the negotiation of linguistic and physical borders. In the midst of 1989's global realignments and paroxysm, Boetti's *World Map* appeared with the immaculate sense of timing.

The meeting with Boetti in 1986 changed my life in a day. One of the first things he advised me to do when in conversation with artists was always to ask them about their unrealized projects. I have done it ever since. Another striking thing about Boetti, which was immediately noticeable, was the rapidity of both his speech and actions. This was especially encouraging for me, as I was often being criticized in Switzerland for

speaking too quickly. Here was someone with whom I had to struggle to keep up. In his studio, with typical velocity, Boetti began to question me about my goals. Because of my recent experience with Fischli and Weiss, I replied that I would like to curate exhibitions, but that I was unsure of how to start.

Boetti told me that if I wanted to curate exhibitions, then I should under no circumstances do what everybody else was doing – just giving the artists a certain room and suggesting that they fill it. What would be more important would be to talk to the artists and ask them which projects they could not realize under existing conditions. Ever since, this has been a central theme of all my exhibitions. I don't believe in the creativity of the curator. I don't think that the exhibition-maker has brilliant ideas around which the works of artists must fit. Instead, the process always starts with a conversation, in which I ask the artists what their unrealized projects are, and then the task is to find the means to realize them. At our first meeting, Boetti said curating could be about making impossible things possible.

Boetti was also the first person to encourage me to read the work of Édouard Glissant, who became my most important theoretical influence. Boetti was attracted to Glissant's preference for differences rather than homogeneity, to the fact that however much maps can be totalizing visions, often tainted with imperialist ambition, they are also always in need of revision. Boetti, accordingly, understood that his maps only recorded a temporary state of world affairs and could not remain accurate over time. As his partner, Annemarie Sauzeau, explained to me: 'flags change design and colour after wars. At that point, Alighiero's maps have to be redesigned.' Maps enfold both the existing and the yet-to-be. This is the inherently metamorphosing nature of maps and map-making; maps are always a door to the future. Boetti's *Mappa* prefigured the cross-cultural

exchange and dialogue (signalled by the text on their borders appearing in Italian or Farsi) that would soon become the stock-in-trade of the rapidly globalizing art world.

This leads to Boetti's other obsession, with the twin poles of order and disorder. He conceptualized systems of order and disorder in his works, in which the one always simultaneously implies the other. Boetti once compiled a list of one thousand of the world's longest rivers, published as a book in 1977. It is a very thick book, a thousand pages long, with many references to river sources on each page. But, due to the meandering, changing course of rivers, their length can never be precisely established. Thus what the book quixotically reveals is that there is no absolutely fixed length of a river, nor a single reliable source, but rather multiple and varying sources. This project involved immense geographic and scientific research, but with a preordained ambiguity in the results. The order that has been created is, at the same time, disorder.

Soon after I arrived at his door, we were in Boetti's car, racing through the streets of Rome so he could introduce me to other artists. He mentioned that a young curator could find great value not only in working in a museum, a gallery, or on a biennial, but also in making artists' dreams come true. I think that was the most important mission he instilled in me. Boetti kept saying, 'Don't be a boring curator.' He told me that one of his main unrealized projects was to do an exhibition for one year in all the planes of an airline, so that they would be flying the exhibition around the world every day and, in some cases, returning each evening. And in this context he wanted to present a serial work that featured aeroplanes, in which you see one plane in the first image, and then you see more and more planes until the sky of the canvas is filled with them.

At the time, I was too young to help Boetti realize his

ambition. But a few years later I told the (always uncapitalized) *museum in progress* in Vienna about this idea, and we got in contact with Austrian Airlines. The airline allowed us to feature Boetti's images of aeroplanes on a double-page spread in each issue of their magazine (which was published every two months) for one year, so we had six issues for the project. Then, one week before the first edition was going to be printed, Boetti sent me a telegram from Milan, where he was working on a large bronze sculpture, and said that the images in the magazine were not sufficient. We needed to add something more physical than the mere magazine page, he continued, and his idea was that we should create a jigsaw puzzle. Now, a puzzle featuring many aeroplanes in the sky would be very easy to solve – but a jigsaw of one monochrome blue and only one plane in it would take hours to solve.

And so we produced various jigsaws of the different aeroplane motifs, with escalating degrees of difficulty. They were exactly the size of the seat-back tables of the aircraft, and they were given away for free for a year on every flight of Austrian Airlines. The airline began with an edition of 40,000 and later reprinted the jigsaws. When they finally received the jigsaw featuring the image of only one plane in an expansive sky, it occurred to them that this might trigger a fear or dislike of flying, because none of the passengers would be able to solve it. The jigsaw couldn't even be solved on long-distance flights with several passengers working together. But it was already too late, and so the jigsaws were distributed in the planes regardless. After this interesting experiment, Boetti not only asked me to come up with ideas for different kinds of exhibition space but also addressed to a different audience, to insert art into spaces where it normally isn't found; for example, today you

can find the jigsaws we did for Austrian Airlines at flea markets, as well as in art bookstores and on eBay.

These conversations with Boetti lay behind my first attempts to supplement existing art exhibitions by creating new formats. Of course, those projects lay somewhere in the future, but my first meeting with Boetti had been a revelation because he gave me a sense that there were still many unexplored horizons in working with artists. Through his drive and inspiration, I had glimpsed the ways I might become a curator and still create something new. Not only did he instill in me the necessity of urgency, but my first ideas of what might still urgently need doing.

Mondialité

Édouard Glissant, who was born on Martinique in 1928 and died in Paris on 3 February 2011, was one of the most important writers and philosophers of our time. He called attention to means of global exchange that do not homogenize culture but produce a difference from which new things can emerge. Andrei Tarkovsky once said that our times were characterized by the loss of rituals, but that it was important to have rituals in order to find our way back to ourselves on a regular basis. I have a ritual of reading in Glissant's books for fifteen minutes every morning. His poems, novels, plays and theoretical essays are a toolbox I use every day.

The history and landscape of the Antilles form the point of departure for Glissant's way of thinking. The first issue that preoccupied him was national identity in view of the colonial past. That is also the theme of his first novel, *La Lézarde* (1958; English: *The Ripening*, 1959 and 1985). He considered the blend of languages and cultures a decisive characteristic of Antillean identity. His native Creole was formed from a combination of the languages of the French colonial rulers and the African slaves; it contains elements of both but is itself something independent and unexpectedly new. On the basis of these insights Glissant later observed that there are similar cultural fusions all over the world. In the 1980s, in essay

collections such as *Le Discours antillais*,[1] he expanded on the concept of creolization, applying it to the worldwide process of continual fusion. 'Creolization,' he writes, is a process that never stops:

> The American archipelagos are extremely important because it was in these islands that the idea of Creolization, that is the blend of cultures, was most brilliantly fulfilled. Continents reject mixings whereas archipelic thought makes it possible to say that neither each person's identity, nor a collective identity, are fixed and established once and for all. I can change through exchange with the other without losing or deluding my sense of self.

The geography of the archipelago is important for Glissant's thought because an island group has no centre, consisting instead of a string of different islands and cultures. 'Archipelic thought', which endeavours to do justice to the world's diversity, forms an antithesis to continental thought, which makes a claim to absoluteness and tries to force its singular world view on others. Against the homogenizing forces of globalization Glissant coined the term *mondialité* ('globality'), which refers to forms of worldwide exchange that recognize and preserve diversity and creolization.

Many of my exhibitions have been based on these ideas. Particularly in the case of productions that toured worldwide, we wanted to create an oscillation between the exhibition and the respective venue. The exhibitions changed places, but each place also changed the exhibition. There were continual 'feedback effects' between the local and the global. The question is how we can react to each circumstance in such a way as to produce differences rather than assimilation. My exploration of this issue

was inspired by my reading of, and eventual talks with, Glissant. His ideal of 'change through exchange with the other without losing or deluding my sense of self' is something I think curating can help us do.

do it

At a café in Paris one late morning in the spring of 1993, I was talking to the artists Christian Boltanski and Bertrand Lavier. I was twenty-four. We were discussing a particular kind of art, one that had grown remarkably over the last century: art that included not only objects to be displayed, but instructions to be executed. This, we agreed, had challenged traditional understandings of creativity, authorship and interpretation. Boltanski and Lavier had been interested in such practices since the early 1970s; both had made many works that presented directions for action to the viewer, who became the work's performer as well as its observer. This kind of art, Lavier pointed out, gave the viewer a measure of power in the making of it. He added that the instructions also gave life to his works, in a very real sense: they provoked not silent contemplation, but movement and action, amongst the visitors to museums or galleries in which they were displayed. Boltanski saw the instructions for installations as analogous to musical scores, which go through countless repetitions as they are interpreted and executed by others.

Starting with Marcel Duchamp, we began to list instruction-based artworks that came up as we talked – in 1919, Duchamp had sent instructions from Argentina to his sisters in Paris for the creation of *Unhappy Readymades*, such as 'buy an encyclopedia and cross out all the words that can be crossed out'. In the

1920s, László Moholy-Nagy made artworks by giving instructions to sign painters. There was John Cage's 'Music of Changes' (1951), musical pieces in the form of instructions that could be interpreted in multiple ways. In the 1960s, Yoko Ono published her groundbreaking book of instructions for art and life, *Grapefruit*. George Brecht proposed that scores be published in the newspaper and so made available to anyone, while Alison Knowles created works she called 'event scores'. Then there was Seth Siegelaub's *January Show*, a 1969 exhibition in the form of a Xeroxed booklet including statements such as Douglas Huebler's 'the world is full of objects. I do not wish to add any more.' Many literary movements, we remembered, also used instructions, such as the Surrealists' famous game of exquisite corpse from the 1920s, in which a poem is written by a group as they add sentences one after another. Automatic writing also made use of instructions, as did Frank O'Hara's 'things-to-do' poems in the 1950s and early 1960s. The Situationists, the radical French group led by Guy Debord in the 1960s, used to produce parodic 'operational instructions'.

As our recitation continued, an idea coalesced, as so often happens out of repetitive list-making: perhaps, we supposed, one could create an exhibition consisting exclusively of do-it-yourself descriptions and procedural instructions, a global exhibition that would bring in contributors from different backgrounds and disciplines. On our napkins we started to write down the names of artists who we thought could deliver fascinating instructions. We were on the way to making an exhibition that we couldn't fully control, that would exist only as a score, on paper and in our memories, until a venue could be found in which it could be interpreted and enacted anew each time.

do it began in 1993 as twelve short texts, which later that year

we translated into eight languages and printed in an orange, notebook-like catalogue. In 1994 the first *do it* exhibition took place, designed by the artist Franz Erhard Walther at the Ritter Kunsthalle in Klagenfurt, Austria. Soon after, it began travelling to other cities: Glasgow, Nantes, Brisbane, Reykjavik, Siena, Bogotá, Helsinki, Geneva, Bangkok, Uppsala, Talinn, Copenhagen, Edmonton, Perth, Ljubljana, Paris, Mexico City, and twenty-five cities in North America. The archive of instructions kept expanding as new contributors were invited to participate. Because the idea and results of *do it* changed with each destination, it became a complex and dynamic learning system, with many local differences. It nevertheless remained organized around a few 'rules of the game' that ensured a certain continuity: for one, each museum had to create at least fifteen of the original thirty potential artworks. Leaving the process of the instructions up to each institution ensured that a new group constellation emerged each time the exhibition was presented.

Realizing the artworks, in the sense of actually executing the instructions, was left to the public or museum staff. The artists who originated the instructions were not allowed to be involved: there would be no artist-produced 'original' that might be considered the 'correct' version, and no traditional artist's signature. To use the punk terminology, it was a DIY (do it yourself) approach to realization: the *do it* artworks would not assume a static character, but would mutate with each new enactment. Also, the components from which the works were made were, at the end of the exhibition, to be returned to their original context, making *do it* completely reversible, or, you might say, recyclable. The mundane was transformed into the uncommon and then converted back into the everyday.

At the end of each *do it* exhibition, the institution presenting

the show was thus obliged to dismantle or otherwise destroy not only the artworks but also the instructions by which they were created, which also removed the possibility of the artworks becoming part of a permanent collection. *do it* appeared, but only in order to disappear. (Each artist who participated, however, received complete photographic documentation of their work.) Our rules of the game were intended to make for an open, exhibition-in-progress model, and each new city in which *do it* took place necessarily created the artwork context and stamped it with its own individual mark or features. *do it* was unconcerned with the notion of the 'signed original', and its opposite, the reproduction or copy – the idea was to focus on the different interpretations. For this reason, no artwork or material was shipped to the venues, as happens in traditional travelling exhibitions. Instead, everyday actions and materials were the starting point for artworks to be recreated at each site. Every realization of *do it* was temporary: an arrangement in space and an activity in time.

Contact zones was my working phrase for what Boltanski, Lavier and I were trying to create. I took it from the anthropologist James Clifford, who had written about a new model for ethnographic museums, in which the peoples whose culture was being 'represented' by the museum proposed their own alternate forms of exhibiting and collecting. They were taking it upon themselves to recollect their own story and create their history from the inside. This changed the whole historical narrative of the ethnographic museum, which has mostly been a place for one culture to tell the story of another. Such museums could be criticized as an exercise in establishment storytelling, of course, so the anti-authoritarian act of including the audience in the production of what was exhibited was of great importance. Similarly, *do it* tried to develop exhibitions that built

a relation to their place, that constantly changed with different local conditions, and created a dynamic, complex system with feedback loops. It changed places and places changed it.

Accordingly, *do it* was conceived to defy the rules that generally govern how contemporary art exhibitions circulate. The dominant idea is that an exhibition is mounted in one city, then taken down and remounted in another in a fashion as close as possible to the first. *do it* was designed to enhance difference and complexity, and propose a different model of thinking about time, in which the goal was no longer to discover the truth and freeze it in amber. No two interpretations of the same set of instructions are ever identical; *do it* simply made this explicit.

In *How to Do Things with Words*, a book based on a 1955 series of lectures, the Oxford philosopher J. L. Austin articulated his theory of 'performative speech acts', which he defined as utterances that perform an action, as opposed to just describing or reporting it. In much of linguistics and the philosophy of language, the general understanding had been that language was a way of making factual assertions, of describing reality. Austin and his followers, such as John Searle, direct us to pay attention to the kinds of work language does in everyday activities: how it creates reality through the production of meaning, rather than simply reflecting a pre-existing meaning itself. *do it* was a development of this research. The title itself, with its imperative form, asks the visitor to act, not only to observe.

do it was, and is, an attempt to expand the field of curating in ways sensitive to the twentieth-century's expansion of the field of art.

Curating, Exhibitions and the Gesamtkunstwerk

A recent article in the food section of New York's main newspaper contained this passage: 'A museum: Chinatown feels that way at times, if you are ducking under the lintel of a basement entrance like Wo Hop's or Hop Kee's to find Cantonese crab or lobster. Sometimes the museum gets an energetic new curator like Wilson Tang, who has made the dim sum standards like char siu bao and cheong fun noodles at his family's Nom Wah Tea Parlor dance again.'

A clothing retailer sells a brightly coloured style of trousers called the 'curator pant', while a brand called 'CURATED' promises 'a new experience in retail design'.

A museum brochure invites members to 'curate your own membership'; musicians and DJs are asked to curate music festivals, radio shows and playlists; hotels' decor schemes and book collections are listed as curated by stylists; a celebrity chef is described as the curator of the food trucks in New York's High Line park.

Social media strategists talk of 'curated and aggregated content'.

A panel discussion comparing the merits of humans and computer algorithms describes how 'the war of humans versus machines has hit the battlefield of online video curation'.

A blog post entitled 'How to Build Your Community with

Content Curation' advises business owners on 'curating content for your business' blog and social media channels'.

The sociologist Mike Davis criticized Barack Obama by describing him as 'the chief curator of the Bush legacy'.

The president of a chain of housewares says 'we act as a curator, scouring the world for what we refer to as "the best-on-planet products"'.

Writing about his poker travails, the author Colson Whitehead reports, 'I wasn't depressed, I was curating despair.'

It's fairly obvious that 'curating' is being used in a greater variety of contexts than ever before, in reference to everything from an exhibition of prints by Old Masters to the contents of a boutique wine shop. Even the verb form so commonly used today, *to curate*, and its variants (*curating, curated*) are coinages of the twentieth century. This records a shift in understanding from a person (a curator) to an enterprise (curating) which is now understood as an activity unto itself. There is, currently, a certain resonance between the idea of *curating* and the contemporary idea of the creative self, floating freely through the world making aesthetic choices of where to go and what to eat, wear and do.

The current vogue for the idea of curating stems from a feature of modern life that is impossible to ignore: the proliferation and reproduction of ideas, raw data, processed information, images, disciplinary knowledge and material products that we are witnessing today. This is hard to overstate. But though the explosive effects of the Internet have now become very obvious, they are only the leading edge of a larger change that has been occurring for about a hundred years.

The exponential increase in the amount of data about human societies is a basic fact of our time. There is no type of information – documents, books, images, video – that is

declining. But in addition, we also create more material goods each year than the previous one. Today we are awash in cheaply produced objects to a degree that would have been difficult to imagine a century ago. The result, arguably, has been a shift in the ratio of importance between making new objects and choosing from what is already there.

This contemporary resonance, however, risks producing a kind of bubble in the value attached to the idea of curating, and has to be resisted. Here I will speak of curating as a profession with a specific history, and touch on moments in that history of curating and exhibition-making as a toolbox for the future.

Dialogues between artists and places, between publics and exhibitions, can be thrillingly catalysed by the forces of globalization. There is an amazing potential for new encounters among today's fast-proliferating array of art centres. Yet homogenization is a danger too, as the French artist Dominique Gonzalez-Foerster has pointed out. For her, exhibitions are a way to resist the pressures towards an ever more uniform experience of time and space, by keeping the visitor in the art moment a little longer.

If that is to happen, it's important to shape exhibitions as projects of long duration and to consider issues of sustainability and legacy. Fly-in, fly-out curating nearly always produces superficial results; it's a practice that goes hand in hand with the fashion for applying the word 'curating' to everything that involves simply making a choice. Making art is not the matter of a moment, and nor is making an exhibition; curating follows art.

Being a curator is considered to be a fairly new profession. The activities it combines into one role, however, are still well expressed by the meaning of its Latin etymological root, *curare*:

to take care of. In ancient Rome, *curatores* were civil servants who took care of some rather prosaic, if necessary, functions: they were responsible for overseeing public works, including the empire's aqueducts, bathhouses and sewers. In the medieval period, the focus shifted to a more metaphysical aspect of human life; the *curatus* was a priest who took care of the souls of a parish. By the late eighteenth century, *curator* came to signify the task of looking after a museum's collection. Different kinds of caretaking have sprung from this root word over the centuries, but the work of the contemporary curator remains surprisingly close to the sense in *curare* of cultivating, growing, pruning and trying to help people and their shared contexts to thrive.

In parallel, the professional curator's role began to coalesce around four functions. The first of these was preservation. Art had come to be understood as a crucial part of a nation's heritage, a set of artefacts that collectively told the story of a country. Thus safeguarding this heritage became a primary responsibility of the curator. The second task was the selection of new work. As time passes, museum collections must necessarily be added to, and the caretaker of the museum thus becomes the caretaker of the national legacy which the museum represents.

The third is the task of contributing to art history. Scholarly research into the works already collected allows the curator to pass on knowledge in modern disciplinary fashion in the same way as the university professor. Finally, there is the task of displaying and arranging the art on the wall and in the galleries: the making of exhibitions. This is the task that has most come to define the contemporary practice; one could even argue that a neologism is needed, so completely has the curator-as-*Austellungsmacher*, or exhibition-maker, departed from the traditional role of caretaking.

For now, however, the idea of curating has become associated more and more closely with the modern cultural ritual we call the exhibition. Exhibitions themselves are a new form, a later addition to the pantheon of classical forms such as drama, poetry and rhetoric. Like novels, they are a practice that became prominent only in the last 250 years. Before 1800, going to look at an exhibition was a very uncommon thing to do; in the twenty-first century, hundreds of millions of people visit them each year.

The art exhibition, in particular, has its roots in the processions of the late Middle Ages, when the flow of people through a city during annual and seasonal festivals provided an opportunity for artisanal craftsmen to display their creations to the passing crowds. In the medieval guilds, apprentices were required to exhibit their best objects in this way. Those whose creations passed the inspections of the master craftsmen were allowed to ascend to the status of journeymen. So the exhibition began as a ritual of professional certification during a time when well-crafted and useful objects were scarce commodities. Therefore it was deeply rooted in the free circulation of people through a public space, which continues to be perhaps its defining feature.

Meanwhile, throughout the Middle Ages, what we know as visual art was not commonly exhibited in public. Royalty and nobility displayed paintings and sculpture at courts, castles and manor houses in order to demonstrate their wealth and importance. In the pre-modern period, the state was of course identified with particular lineages or bloodlines: from the marbles commemorating Augustus Caesar and his family to Hans Holbein's portraits of the English Tudors, sculpture and painting served an important propagandistic function, while the individuals who took care of these pieces, as well as most of

those who executed them (later to be known as 'artists'), worked mostly in semi-obscurity under the patronage of their social superiors.

The wider public typically only came into contact with visual art at places of worship – in the great temples, cathedrals and mosques of the medieval period. In the sixteenth century, official academies emerged in Florence and Rome, which evaluated and classified the art produced in their regions. In 1648 the French Academy began its Salon exhibitions, named after the Grand Salon of the Louvre, where they were held. The Salons were government-sponsored exhibitions of French art, to be evaluated by the public. With the development of democratic states in the seventeenth and eighteenth centuries, art came to be seen as the patrimony of the people, who were thought to be in need of an improvement in manners that calmly looking at paintings represented. Paintings and sculpture needed to be brought to the attention of that new, secular abstraction – 'the public'. And so state-run museums came into being, beginning with the Louvre in 1793.

The first people to play the role of professional exhibition-makers at a museum were the Louvre's *décorateurs* in the eighteenth century. Usually artists themselves, the *décorateurs* were in charge of organizing and hanging artworks for the annual exhibitions of the Academy. They began to standardize the practice of installing museum collections in order to best display both historical developments and thematic similarities. In the late eighteenth century, however, the idea of displaying artworks in order to represent historical progress was being explored for the first time. With the French Revolution the debate took on nationalist overtones, and a mainstream style emerged: a walk from room to room in a museum took the visitor on a journey through the stages of a nation's history.

With the coming of the twentieth century, the style of presentation in museums underwent a major shift, one of the best accounts of which was provided by the artist and writer Brian O'Doherty in a magisterial set of essays in *Artforum* during the 1970s. In the eighteenth and nineteenth centuries, paintings had been hung cheek by jowl in tightly packed formations from floor to ceiling, their gilded frames almost touching, with those placed high on the wall often tilted downwards to meet the eye of the spectator. This was known as the *salon style*, after the academic salons in which it began, and allowed spectators to see dozens of canvases on each wall, emphasizing the taxonomic schools of painting and commonalities of subject matter. In a famous depiction of an 1832 exhibition in the Louvre, Samuel Morse's *Exhibition Gallery at the Louvre*, you can see the *Mona Lisa* juxtaposed with over twenty other canvases on a crowded gallery wall. Each painted image had to have a prominent frame to make clear the boundaries between the pictures on the wall.

The hazy and indistinct paintings of Claude Monet, O'Doherty points out, typify the inauguration of a decisive new epoch in art history in which the horizontal painted surface, rather than the vertical depth of representational images, was primary. Paintings grew larger and larger, taking up more of the wall. According to this new understanding of the unique importance of each artwork, the space in between paintings began to increase. The spectator was to be encouraged to observe the work free from the distraction produced by the proximity of other ones.

Eventually, many paintings were hung on a wall on their own, or with only a few neighbours, rendering the separating device of the frame unnecessary; by 1960 the curator William C. Seitz removed the frames entirely from Monet's paintings for a show

at the Museum of Modern Art in New York. The gallery itself became the framing mechanism. In this kind of modernist art space, the encounter between the spectator and one work dominated. For this reason, other visual cues in the space were reduced to a minimum, resulting in a clean, spare gallery space that we know today as the *white cube*. As O'Doherty writes, 'The history of modernism is intimately framed by that space . . . An image comes to mind of a white, ideal space that, more than any single picture, may be the archetypal image of twentieth-century art . . . Some of the sanctity of the church, the formality of the courtroom, the mystique of the experimental laboratory joins with chic design to produce a unique chamber of esthetics.'

As the gallery itself became understood as the frame for visual art, artists began to innovate and invent display features within this expanded format. Two projects of Marcel Duchamp, in particular, are pivotal here, and each functioned as both an installation and a curatorial project. In 1938 he curated the *International Exposition of Surrealism* in Paris. For the exhibition he hung 1,200 bags of coal from the ceiling of the hall, darkening the space and dominating the exhibition with a radical display feature. In 1942 he curated another show, *First Papers of Surrealism*, in which he garlanded the space with spiderweb-like fibres. As his then collaborator, Leonora Carrington, told me, it was a wry joke at the obsolescence of painting and sculpture in any simple form. *1200 Bags of Coal* and *Mile of String* both treated the exhibition itself as the relevant carrier of meaning. They foreshadowed the late twentieth-century's understanding of gallery space and further expanded the meaning of the space so that artists began to treat sets of rooms or even entire museums as the context for a work.

Duchamp's masterwork, *The Bride Stripped Bare by Her*

Bachelors, Even (The Large Glass), created between 1915 and 1923, was at the centre of an exhibition that particularly struck me, which I would go to see whenever I could escape from school. I was fourteen at the time. The exhibition was *Der Hang zum Gesamtkunstwerk* – which means 'a tendency towards the total work of art'. From February through April 1983 this exhibition, curated by Harald Szeemann, took place at the Kunsthaus Zürich, and I ended up visiting it forty-one times. It was an encyclopedic exhibition and a non-didactic attempt to create, as Szeemann said, 'poems in space'. It was the most important exhibition I saw during my adolescence, and one of the reasons I became a curator.

The exhibition traced the *Gesamtkunstwerk* as a utopian idea from around 1800 to the present. It began with the French Revolutionary architecture of Étienne-Louis Boullée and the German Romanticism of Philipp Otto Runge and Caspar David Friedrich. It featured a large variety of all-encompassing artworks and the documentation of works in many media: the composer Richard Wagner's Ring Cycle; the systemic thought of the theosophist Rudolf Steiner; the artist and choreographer Oskar Schlemmer's *Triadic Ballet*; Kurt Schwitters' sculptural city *The Cathedral of Erotic Mysery* and his vast, architectural *Merzbau*; the plans of the visionary architect Antoni Gaudí; the 'Gläserne Kette', a chain letter between Bruno Taut and fellow architects; the writings of Antonin Artaud; artworks by 'outsider' artists like Adolf Wölfli or the Facteur Cheval; and much more.

In the centre of the exhibition space, Szeemann placed what he described as 'a small space with some of the primary artistic gestures of our century': Duchamp's *The Bride Stripped Bare by Her Bachelors, Even*, a 1911 painting by Vassily Kandinsky, one by Piet Mondrian and a Kasimir Malevich. This small room was like a chapel, a meditation on masterworks. The exhibition

ended with Joseph Beuys' social sculpture, and with him the perspective opened up to the present. Szeemann called the exhibition 'a tendency towards the *Gesamtkunstwerk*' because the *Gesamtkunstwerk* per se, as he said, can exist only in imagination: it can never actually be realized. In the catalogue, he wrote, the *Gesamtkunstwerk* shows a desire to produce a total picture or to realize an entire universe. The exhibition, Szeemann stressed, was meant to be the opposite of this totalitarian desire: it was, he wrote, 'an invitation to a walk through the valley of styles on the rise; despite the different forms of power, something of an Olympian calm prevails'.

The exhibition architecture consequently contained a real polyphony of positions that created fascinating associations across the different historic positions. The 'Gläserne Kette' could be connected to Runge, Beuys could be connected to Steiner, and so forth. The space presented different 'worlds inside the world', like a Russian *matryoshka* doll. Be it Ferdinand Cheval or Kurt Schwitters, they created worlds inside the world. This is probably the fundamental idea of the *Gesamtkunstwerk*: to create a self-contained world.

Der Hang zum Gesamtkunstwerk was built upon other exhibitions that Szeemann had curated earlier. In 1975 he curated *Junggesellenmaschinen (Bachelor Machines)* at the Kunsthalle Bern. Szeemann remarked that he 'was inspired by Duchamp's *Large Glass* and similar machines or machine-like men, such as those in Kafka's short story "In the Penal Colony", Raymond Roussel's "Impressions d'Afrique", and Alfred Jarry's "Le Surmâle", and it had to do with a belief in eternal energy flow as a way to avoid death, as an erotics of life: the bachelor as rebel-model, as anti-procreation'.

The second forerunner was *Monte Verità: Le mamelle della verità (Monte Verità: The Breasts of Truth)* in Ascona, Switzerland,

in 1978. Around the year 1900 the hill had become an artist's colony where many of the protagonists of the great utopian efforts in art and society met: the artists of 'Die Blaue Reiter' and the Bauhaus, inventors of modern dance like Rudolf Laban, the theosophists around Rudolf Steiner, the members of the 'life reform' movement, and anarchists like Mikhail Bakunin. They came from the north and wanted to realize their utopias of the sun in the south. Szeemann said about the later history of the *Monte Verità*: 'Ascona is a case study about how fashionable tourist destinations get to be produced: first you have a set of romantic idealists, then social utopias that attract artists, then come the bankers who buy the paintings and want to live where the artists do. When the bankers call for architects the disaster starts.' The questions of artistic and social utopias posed by *Monte Verità* were then further explored in *Der Hang zum Gesamtkunstwerk*.

An exhibition like *Der Hang zum Gesamtkunstwerk* was an arrangement of important and disparate works of art, but within it one can also clearly detect a singular and distinctive cultural voice. You could learn from it, agree with it, disagree with it, defend it. Its power comes from the subtle sources of juxtaposition and arrangement. Most of all, it makes no pretence to being capable of producing something of value alone. The very idea of an exhibition is that we live in a world with each other, in which it is possible to make arrangements, associations, connections and wordless gestures, and, through this *mise en scène*, to speak.

Yet here we must sound a note of caution. The danger with a large group exhibition is that it can be seen as the exhibition-maker's own *Gesamtkunstwerk*. By the 1980s many thematic exhibitions risked being seen this way, the curator as an overriding figure or *auteur* who uses artwork to illustrate his

or her own theory. Artists and their works must not be used to illustrate a curatorial proposal or premise to which they are subordinated. Instead, exhibitions are best generated through conversations and collaborations with artists, whose input should steer the process from the beginning. Another positive development is the co-curating of exhibitions by multiple figures. Whereas in Szeemann's generation the curator was often a singular figure, today many exhibitions are marked by a collaboration between multiple curators.[2]

Recounting the actual history of curating and exhibitions can help us steer clear of a related confusion: that the curator herself or himself is an artist. It is true that the exhibition format has become more recognizable and popular, and exhibition-makers have come to be identified as individual makers of meaning. As artists themselves have moved beyond the simple production of art objects, and towards assembling or arranging installations that galvanize an entire exhibition space, their activity has in many cases become more consonant with the older idea of the curator as someone who arranges objects into a display.

These developments have given rise to an impression that curators are competing with artists for primacy in the production of meaning or aesthetic value. Some theorists argue that curators are now secularized artists in all but name, but I think this goes too far. My belief is that curators follow artists, not the other way around. The role of the artist changed greatly over the last century. The artist Tino Sehgal has said that the notion of art generated by sculptors and painters in the early nineteenth century, and fully articulated and established by the 1960s, is detaching itself from its material origins and venturing into other realms in the twenty-first century. The exhibition-maker's role has expanded in turn. Curating changes with the change in art.

That said, the role of exhibition-maker is one sometimes played by artists themselves. In 2006, Jean-Luc Godard curated a show for the Pompidou Centre in Paris, which turned out to be one of the most radical experiments the Centre had mounted since Jean-François Lyotard's *Les Immatériaux* exhibition in 1985. The museum had already played a role in Godard's work since his film *Bande à Part* (1964), with its famous sequence of the lead characters running through the Louvre. His exhibition was a non-retrospective retrospective, in which he planned to look at the history of cinema, the hegemony of American popular culture and the hegemony of images.

I visited the exhibition many times, a bit like *Der Hang zum Gesamtkunstwerk* some twenty years earlier. Godard's show revealed how to change the rules of the game and unsettle most conventions of the format. The exhibition started with a series of disclaimers that it was not suitable for all audiences and warnings not to take kids into the last room. Godard's partially hand-corrected wall text made clear that the original idea of the show he had wanted to curate remained unrealized – the initial title was *Collage(s) de France: Archeology of Cinema*. The exhibition wasn't put on due to the technical and financial difficulties it presented, so Godard replaced it with *Travel(s) in Utopia JLG 1946–2006: In Search of Lost Theorem*.

About six months before the opening, Godard declared that he had fired the curator working with him on the show. From this moment onwards, he refused all other dialogue with the Pompidou Centre other than handwritten faxes. Godard later refused to allow a press release. The final show was never final as it kept changing throughout its duration: there were cables lying around and other installation elements of the process so that the show looked forever unfinished. Visitors entered by parting heavy plastic curtains. It was chaosmotic, to use Felix

34

Guattari's word for an experience of osmosis in an environment of constant change – the history of cinema is nothing if not that.

Godard included original paintings from the museum's collection, from Henri Matisse to Nicolas de Staël, situations like a bed with pillows, models of the unrealized show and the realized show, waste and posters, many film posters, and a number of flat plasma screens with fragments from his films and other films. Godard included a room, labelled AVANT-HIER ('before yesterday'), with abandoned maquettes of the original, unrealized exhibition, *Collage(s) de France*. In the room HIER ('yesterday') he showed many filmic fragments from his own and other films. And in the room entitled AUJOURD'HUI ('today') he included plasma screens showing sports, pornography and found situations such as the bed. The show was an imaginary space of past and present coming together, as an exhibition should be.

Courbet, Manet and Whistler

In the second half of the nineteenth century, artists themselves were to play the most important role in the transformation of the exhibition format. In 1855, Gustave Courbet submitted nine paintings to the Academy for inclusion in that year's Salon. The Salon exhibitions had become the most important venue for French painters to exhibit their works, and it inspired the development of what we now know as art criticism. Between 1759 and 1781, Denis Diderot had published a set of newsletters reviewing each of the Salon exhibitions. These writings marked the beginning of the understanding of exhibitions as publicly received events whose contents could be assessed in terms of newness, originality and vitality. By the nineteenth century, figures such as Charles Baudelaire and Émile Zola were emphasizing the Salon's importance by writing about the painters they saw there.

Courbet was frustrated by his lack of recognition from the Academy, which was the only way for an artist to earn credibility in nineteenth-century France. The style favoured by the Academy involved the use of large canvases for 'important' subject matter, such as historic, mythical scenes. Courbet did not abide by this hierarchy of values; his large-scale painting *Burial at Ornans* had shocked audiences in 1851 by showing the humble residents of his home town in a manner normally reserved for

the social elite. In 1855 he submitted a similarly radical canvas, an allegorical portrait of himself entitled *The Artist's Studio*.

The Artist's Studio was rejected by the Academy. In response, Courbet decided to take matters into his own hands. He erected a temporary structure near the Salon and installed forty-four of his paintings in it, calling his exhibition the *Pavilion of Realism*. Courbet's self-mounted exhibition inaugurated the modern period in painting, in which the artist, rather than his patron, became the protagonist of art. Equally importantly, he helped to free public exhibitions from the sole authority of the state.

Within ten years further revolts against the hegemony of the Academy occurred. Protests by artists led Napoleon III to mandate that rejected artists be allowed to show at the other end of the official exhibition hall. This led to the 1863 Salon des Refusés, which showed the works of artists including Paul Cézanne, Pierre-Auguste Renoir, Camille Pissarro and Edouard Manet, who had been refused from that year's official exhibition. The exhibition featured some of the century's most celebrated works, including Manet's *Déjeuner sur l'herbe* (1862–3).

'To exhibit is to find allies for the struggle,' Manet remarked. Whereas in the Salon's traditional format paintings were hung from floor to ceiling, covering an entire wall, Manet believed that paintings should be hung in at most one or two rows, with space left between them to allow viewers to concentrate on a single work, rather than a jumbled assemblage. Courbet's and Manet's self-organized shows intervened directly in the discourse surrounding what counts as art, rather than leaving it up to 'authorities'. Courbet and Manet had begun to act as curators. They are the predecessors of today's many artist-run spaces.

A third artist who expanded the field of art in the nineteenth century was James McNeill Whistler. When a wealthy ship-owner named Frederick Leyland and his interior architect,

Thomas Jeckyll, consulted Whistler for help decorating the London dining room where Leyland displayed his collection of Chinese porcelain, they also commissioned a Whistler painting called *La Princesse du pays de la porcelaine* (1863–4).

Whistler set to work, repainting the walls with yellow, then decorated the room with a wave pattern. After Leyland left on a trip to Liverpool, Whistler installed an imitation gold-leaf ceiling, then painted it in a pattern of peacock feathers. Leyland returned to find Whistler treating the entire room as an artwork – a kind of early *Gesamtkunstwerk* – and so began a predictable dispute over payment. Whistler went right ahead and incorporated this too, by painting a mural showing a pair of warring peacocks representing himself and Leyland, which he titled *Art and Money; or, The Story of the Room*. Whistler's overstepping of his boundaries created one of his famous artistic efforts, *The Peacock Room*. It prefigured installation art, in which an artist works on the entire environment of a space, rather than simply decorating a part of it with a painting or sculpture.

Courbet, Manet and Whistler each played an important role in the emerging field of exhibitions and installation, laying the groundwork for the artist-run space, the modern concept of hanging works of art, and the idea of the room as a total unit under the control of the artist. In so doing, they brought the display of artworks into the realm of individual agency, making it possible to conceptualize a role which became distinct from that of the artist, a role with responsibility for the overall arrangement and presentation of groups of artworks within an aesthetically unified space. In the twentieth century the rethinking of art and its display was influenced by their modernizing efforts.

Collecting Knowledge

To make a collection is to find, acquire, organize and store items, whether in a room, a house, a library, a museum or a warehouse. It is also, inevitably, a way of thinking about the world – the connections and principles that produce a collection contain assumptions, juxtapositions, findings, experimental possibilities and associations. Collection-making, you could say, is a method of producing knowledge.

During the Renaissance, private citizens collected items of note in their own homes, usually in a specially designated room known as a *Wunderkammer*, or cabinet of curiosities. Aristocrats, monks, scholars, academicians, natural scientists and wealthy private citizens: the slightly motley group who made up the early modern public sphere were the initial protagonists. The compulsive interest of such people in collecting expressed itself as a drive to collate and understand significant objects: the fossils, minerals, specimens, tools and artisanal products that provided evidence for our knowledge of and theories about the world. And without modern institutions like the British Library or the Natural History Museum in London, or the Library of Congress in Washington, it fell to interested parties to take up this job themselves.

Though the aim of amassing evidence may sound like a rather scientific way to think about collecting, it is necessary to

remember that the hard distinction between science and art which marks more recent centuries was not evident as late as the sixteenth century. The separation of art and the humanities on the one hand, and science on the other, is a fundamental feature of modern life, but it also constitutes a loss.

Looking back in time can be an invaluable tool for this: pre-modern scholars had a more holistic and comprehensive picture of human life than we do today. The hard division between the rational and irrational that marks modernity has rendered unclear how science and art might relate to one other, how each is, perhaps secretly, part of the other. The history of the *Wunderkammer* – in which artefacts, paintings, specimens, sculptures and geological samples were collected in one place – is also the history of the period in which *explanations*, *facts* and the scientific method were first being seriously studied. To study the Renaissance is to gain a model for reconnecting art and science, sundered by history.

The *Wunderkammer* presented, in a room or suite of rooms, miscellanies of *curiosities*, those objects that were mysterious or strange. A recent exhibition text described their typical contents: 'animal, vegetable, and mineral specimens; anatomical oddities; medical diagrams; pictures and manuscripts describing far-off landscapes, strange figures and animals, or beasts from fable and myth; plans for impossible buildings and machines'.

These early collections of all forms of knowledge appear remarkably omnivorous to our modern, specialized selves. The Renaissance scholar, scientist and *Wunderkammer*-maker Athanasius Kircher is a striking example of this type of omnivore. I first came across Kircher's work in my childhood, in the monastery library in St Gallen, and his knowledge of many different fields of activity fascinated me. Born in 1602, Kircher studied and contributed to the understanding of geology, optics,

astronomy, perpetual motion machines, Chinese culture and history, clock design, medicine, mathematics, the civilization of ancient Egypt, and an amazing array of other subjects. Among a number of activities, he produced diagrams proving that the Tower of Babel could not reach the moon, and had himself lowered into the crater of a rumbling, soon-to-erupt Mount Vesuvius to gain a better understanding of volcanic activity.

Kircher assembled a large collection of curiosities outside Rome, known as the Museum Kircherianum. There he installed a speaking tube, which connected his private bedroom with the exhibition rooms. When visitors came, he could be informed and attend to them. In the period before the connection between museum-going and the public sphere, Kircher's system was a kind of early hybrid between private and public, and between him being a private host and a public museum official. He was probably the most famous intellectual investigator of his time, and his interests, unimaginably diverse to us today, would have appeared to his contemporaries as the impulses of a natural philosopher. His many books, and the many beautiful drawings he produced, are now seen as part of the history of science and of aesthetics.

Today, such important collections are stored in public institutions: in the seventeenth and eighteenth centuries, the idea of a collection that belonged, as a kind of inheritance, to the citizens of a democratic state, came into being. The British Museum, for instance, originated from the massive collection of Hans Sloane, a capitalist, physician and botanist. Sloane personally collected plant and animal specimens from Jamaica, and to this core he added other collections. He amassed hundreds of volumes of plants, as well as precious stones and animals, all of which he left to England at his death in 1753. From such collections, the first public museums inherited their aspiration to

contain *everything*, to bring representations of all the world's diversity under one roof. Their descendants are museums such as New York's Metropolitan Museum of Art, with its Polynesian canoes, Impressionist paintings, Japanese suits of armour and Egyptian Temple of Dendur. The aspiration to completeness was also the principle behind the Victoria and Albert Museum's room full of plaster casts of monuments, including a 'life-size' cast of Trajan's column so large it had to be cut in two.

The effort to organize and explain the world's copious and strange complexity is the common desire underlying the *Wunderkammer* – but equally evident is the desire to luxuriate in what cannot be understood. Even if we have, today, split apart the scientific from the artistic, the *Wunderkammer* reminds us that the two are both essentially forms of taking pleasure in the task of understanding the world, provoked by a stimulating object or idea. As the artist Paul Chan told me, 'curiosity is the pleasure principle of thought'. Both art and science require and call into being an *archive* of such objects and ideas, which is what Kircher, Sloane and others like them produced. This archive, in a typical *Wunderkammer*, is heterogeneous, unedited, and contains artworks embedded with non-artworks, artificilia with naturalia – any and all objects whose curiousness incited a quest for understanding.

Public state museums are a phenomenon of the late eighteenth century – the first major public art museum being the Louvre – but museums also existed in antiquity; the original meaning of the term is a place consecrated to the muses. The famed library of Alexandria is the oldest known museum; the connection between museums and libraries, then, is an ancient and intimate one. By the Renaissance, Kircher and other scholars were using 'museum' to refer to any place or object – a study, a library, a garden, an encyclopedia – where items were

collected for learned study. Museums were supposed to be an objective archive of the past. By the late nineteenth century, walking through a series of interconnected rooms in a museum was understood as a journey through time, through stages of development that tell the story of history. But this does not mean the museum is simply a resting place – in the twentieth century the institution has recovered this multiplicity of roots.

Of Libraries and Archives

I grew up in the eastern part of Switzerland near Lake Constance and was first exposed to the idea of a *collection* by libraries. Before I discovered museums, my parents often took me to the Stiftsbibliothek, a monastery library about 40 kilometres away in St Gallen. The monastery library, a large baroque hall from the seventeenth century, contains books that date back to the ninth century. My child's mind was very deeply attracted to and marvelled at this library, its collection of medieval books, the white gloves worn by its staff, the readers forced to walk silently wearing felt slippers. These are indelible images for me. In its completeness, the monastery's collection represented the dream articulated by Athanasius Kircher: that we could have all the world's knowledge united in one place – and in one person. The monastic collection inspired me, and I was soon collecting books myself. I bought many, and by high school you could hardly get into my room – from the beginning my interests in literature, visual display and collection were intermingled.

One of the monastery library's most famous holdings is a ninth-century map known as *The Plan of St. Gall*, which is the design of the monastic cloister. It contains plans for the monks' kitchen, their library, their living spaces and so on. Human

beings have a prodigious ability to memorize spaces. The plan is very much about archives – for the medieval mind, space was also a way to store memories.

A second library that fascinated me as a child was an import-ant bridge between the literature and the visual arts. This was the Erker-Galerie, a gallery and bookshop in St Gallen. Its dir-ector, Franz Larese, had been a book dealer and took special pleasure in bringing together artists and writers. The philos-opher Martin Heidegger, for instance, did a record with the sculptor Eduardo Chillida. One of the most famous occurrences at the Erker-Galerie was a speech in 1961 by the leading play-wright of the theatre of the absurd, Eugène Ionesco, who at an exhibition of his friend the painter Gérard Schneider denounced openings and speeches. In short, it was a place of great creative ferment which brought together the artistic worlds of the twen-tieth century, all near my home town.

One evening, on the street in front of the gallery, I happened to begin speaking to a man who turned out to be Ionesco him-self. Remarkably, he had stopped writing. In his seventies, he was now drawing, painting and producing lithographs. I was struck again by the interpermeability of the creative worlds, and Ionesco-the-real-person's lack of regard for the supposed calling of Ionesco the world-famous playwright. During our conversation that night he told me that one of his plays, *La Cantatrice chauve* (*The Bald Prima Donna*), had been performed every night in a small theatre in Paris since 1957. It continues to this day, and is widely considered the longest continuously run-ning play in one theatre in history. As a teenager on the street, to meet Ionesco and hear this story made a deep impression – plays and exhibitions, which I assumed always ended after a few months or travelled for a couple of years, could be

structured in such a way as to last for time spans more akin to sculptures in a museum. Entirely different time frames were possible.

In a long published conversation between Umberto Eco and Jean-Claude Carrière, during which they discuss archives, the writers say that everything they've thought about such collections started with their childhood, and they also discuss the biggest problem with archives: where to put them. Eco's own archival dilemma became so bad that he actually needed to buy an apartment just to put his books. As Eco describes the problem in *This is Not the End of the Book*:

> I once did some calculations about this, it was quite a while ago and I should probably do it again. I researched the price per square metre of a Milan apartment that was neither in the old town – too expensive – nor in the poor suburbs. I had to get my head around the fact that the nice reasonably bourgeois apartment would cost me six thousand Euros per square metre or three hundred thousand for an apartment of fifty square metres. I then subtracted the doors, windows and all elements that cut down on the apartment's vertical space, mainly the walls that might host bookshelves, and that left me with only twenty-five square metres, so one vertical square metre would cost me twelve thousand Euros. I then researched the cheapest price for a six-shelf bookcase, which was five hundred Euros per square metre. I could probably store three hundred books per a six-shelf square metre, the cost of storing each book therefore would be about forty-two Euros, more than the price of the book itself. So each person who sent me a book should include a check for that amount.

Obviously, his story speaks volumes about the fact that so many archives are still homeless.

There is another problem with archives. As the late architect Cedric Price pointed out, the twentieth century entertained an obsessive desire for architectural and artistic permanence based around structures that could be preserved forever. The twenty-first century, I believe, will increasingly question this fetishization of the object. The architectural and artistic contributions that are going to endure are not only the ones with a built physical form. It is not only a question of objects but a question of ideas, a repository of ideas and scores.

In a conversation I had with her some years ago, Doris Lessing questioned the future of museums. It's not that she was fundamentally opposed to them; rather, she worried that their prioritization of material objects from the past might not be enough to convey functional meaning to tomorrow's generations. Her 1999 novel, *Mara and Dann*, is premised on the aftermath of an ice age thousands of years into the future that has eradicated all life in the northern hemisphere. The protagonists, long since confined to the other side of the globe, embark upon a journey into this now desolate terrain but they are at a loss to understand its remnants; they have no grounding in its culture and artefacts. This is Lessing's fictional portrayal of her belief that 'our entire culture is extremely fragile' – the more dependent it becomes on increasingly complex devices, the more susceptible it is to a sudden collapse. In light of this, Lessing urges us to take pause and to reconsider the capacity of our language and cultural systems to be meaningful to those beyond our immediate public.

Since 1990 I have gathered information on an unusual species

of art: unrealized projects. Unlike unrealized models and projects submitted for architectural competitions, which are frequently published, such endeavours in the visual arts – that are planned but not carried out – ordinarily remain unnoticed or little known. But these roads not taken are a reservoir of artistic ideas: forgotten projects, directly or indirectly censored projects, misunderstood projects, oppressed projects, lost projects, unrealizable projects.

There are many reasons why the projects about which I gathered information have not been executed. Public commissions are the most common type, and they usually entail postponement, censorship or rejection by the government agency in charge of the project. There are also desk-drawer projects developed by artists without reference to a particular commission, many planned but then forgotten or even rejected by the artists themselves. As the philosopher Gilles Deleuze argued, each process of actualization is surrounded by a constantly thickening fog of virtual possibilities. Missed opportunities and failed projects also fall into this category. As a rule, unsuccessful works remain totally unknown, as success is a more popular topic of discussion than failure.

Here are a few examples. Gerhard Richter wanted to exhibit a readymade object: 'A motor-driven clown doll, about 1.5 meters tall, which stood up and then collapsed into itself.' Louise Bourgeois wanted to build a small amphitheatre. Nancy Spero created billboards for display in New York City but they went unrealized due to censorship. Pierre Huyghe wanted to execute a project to be called 'The Family Film Series'. He planned to reprogramme an abandoned small-town cinema to show the residents' home movies continuously. As he explained, he was 'doing that in a small city, so

that everybody would show up in each other's films, the neighbor in the background, a co-presence and a collective auto-portrait of a town'. Eventually, Guy Tortosa and I edited the hundreds of unrealized projects into a book-exhibition called *Unbuilt Roads*.

Printed Exhibitions

The idea of the book as an exhibition brings us to the curators Lucy Lippard and Seth Siegelaub. During my first trip to New York, in the late 1980s, I spent a lot of time in bookstores, and acquired several books by and about Lippard and Siegelaub. Through them, I first came across the idea that exhibitions can be immaterial, and be held outside museums and exhibition spaces. In the 1960s, Lippard, at the time a librarian and archivist, was living in New York City with a community of artists and friends, like Robert Barry and Sol Lewitt, who were experimenting with new forms of art production. They and others of their generation thought visual art could move beyond objects, typically paintings or sculptures, and could be found, especially for Lippard, in the social life of cities and communities.

In the late 1960s and early 1970s, Lippard organized what have come to be known as her 'numbers' shows, exhibitions that took the total population of the city in which they were shown as their title. With the numbers shows, Lippard hoped to 'democratize' art in some way, and transform the activity of art-making into something experienced daily by the inhabitants of the cities where she staged her shows, taking artworks outside of the museum system, the loci of privileged taste and power, into the streets and parks and fields. These were endeavours that sought to expand the site of art beyond the constrictive frame of

the museum, encompassing works that were installed in a fifty-mile radius around a given city. The first of these shows, 557,087, was set up in Seattle in 1969. Due to budget limitations, Lippard executed most of the works herself, with a team of helpers, according to instructions from the artists – but this gesture also made sense of ideas behind the works, which were created during a time when there was a significant shift towards dematerialized art practices.

The 557,087 show travelled to Vancouver and became 955,000. The catalogues for both shows took the form of a randomly organized stack of index cards – one card for each of the artists, but also cards with aphorisms, lists and quotes. The idea was that the reader could choose the order in which to read them, just as he or she could choose how to navigate the unruly size of the exhibition.

Lippard has said of her numbers shows, 'I have in mind the arguments Robert Smithson and I had on finity versus infinity (as though you could argue about such a thing): he was for finity; I was, idealistically, for infinity.' Lippard's work has been marked by an attempt to imagine and execute an expansion of the frame of art beyond the reaches of the museum and art world. One of the earliest exhibition projects she planned, in 1968, was an attempt to find alternative circuits or modes of distribution for art with a 'suitcase exhibition' in Latin America. 'I was trying to do shows that would be so dematerialized they could be packed in a suitcase and taken by one artist to another country,' she later commented, 'then another artist would take it to another country, and so on, so artists themselves would be hanging these shows and taking them around and networking. We would bypass the museum structure.'

Always a political exhibition-maker, Lippard continued to expand her practice away from the metropolitan centres of the

art world. She now lives in a village in New Mexico with a population of 265, where she writes community newsletters and is involved in land use, planning and watershed politics. She writes about local artists for catalogues, and has been working on a number of books that chart the archaeology and history of ancient Pueblo sites and ruins of the area. Lippard has also written a study of the American landscape, arguing that a single place or locality is underpinned by multivalent meanings, emphasizing the need to work against the homogenization of our cultural spaces and the responsibility we have for valuing their underlying historical meanings and uses.

Another exhibition-maker investigating the meaning of archives was the inventive Seth Siegelaub. A key word of Siegelaub's practice in the 1960s was 'demystification': the idea that an exhibition-maker should attempt to understand and be conscious of the way their actions played a part in the production of meaning within a given exhibition. If the power of such an individual to choose artists and works often operates invisibly, Siegelaub and Lippard nevertheless tried to demystify this process – that is to say, take responsibility for and make evident to the viewer the effect of decisions they had taken that imparted meaning to their exhibitions.

In 1964, Siegelaub opened his own gallery in New York, Seth Siegelaub Contemporary Art, but he soon found that the pressure of putting on eight to ten shows a year as well as running a permanent space meant that there was little time for looser forms of thought and play. Two years later he closed the gallery and became a private dealer allied closely to a group of Conceptual artists including Robert Barry, Douglas Huebler, Joseph Kosuth and Lawrence Weiner. He worked with them to devise exhibition structures that would reflect the nature of their

work, and found that the gallery context was not necessarily the ideal way of showing it.

In 1968, for the so-called 'Xerox book' project, a group exhibition in book form, Siegelaub came up with specific requirements for each of the seven artists involved to work within: they were asked to make a 25-page work on 8½ x 11-inch paper to be photocopied and printed. The intention was that by standardizing the conditions of exhibition and production, the differences between each artist's project would be more pronounced and that it would be specifically in those differences that the meanings of the works would lie. Furthermore, this project tackled the problem of representation via the traditional means of reproduction (e.g. photography) of works of art in books: because in this case the original work was in fact a reproduction in itself (a photocopy), its integrity as art was not compromised when it was reprinted and mass-distributed in the book.

With this and other projects, Siegelaub used mass-media formats in order to set up new kinds of art encounters: the viewer did not necessarily need to make a journey, pilgrim-like, to the sacred gallery space. Works were available to audiences across great geographical distances, in reproducible forms. An intriguing side effect of this process was that publicity material for an exhibition of Conceptual art took on the status of art proper, defined by Siegelaub as 'primary information' about the works. His advertisement for Douglas Huebler's November 1968 exhibition both documented the show and became a material part of it, synonymous with the art.

In 1970, Siegelaub organized another group exhibition in print, this time for the journal *Studio International*. He asked six art critics (David Antin, Charles Harrison, Lucy Lippard, Michel Claura, Germano Celant and Hans Strelow) to each edit an

eight-page section. He thereby took himself out of the process of selection, which is traditionally the domain of the curator, paradoxically as a way of making the role of the curator more visible and more aware of his part in the exhibition process.

At the same time Siegelaub, like Lippard, was also becoming politically active and in 1971 he worked with Bob Projansky to produce The Artist's Contract (The Artist's Reserved Rights Transfer and Sale Agreement). The intent of this project was to shift the art world's power relations more in favour of the artists themselves by giving them greater control over their work once it left their studio.

Infinite Conversations

Alighiero Boetti died in 1994. I was affected by his death as the immense personal loss of my mentor, but also as the loss to the public of an encouraging, stimulating presence. As an artist, he had left behind many works, but he himself as a speaking subject was forever gone. I immediately regretted that all the conversations we had had were suddenly no more, that there was no record of his unique way of expressing himself, his ways of making connections. Almost everything I had done was born out of conversations. I started thinking it would be a good idea to create a trace of my core activities. And that's when I started to make systematic recordings.

When I was a student, I read several very long conversations that have stayed with me ever since. One was between Pierre Cabanne and Marcel Duchamp; another was between David Sylvester and Francis Bacon; a third, between Brassaï and Pablo Picasso. I also read many of the interviews with writers in the *Paris Review*. These three books of interviews, somehow, brought me closer to art – they were like oxygen, and were the first time that the idea of a conversation with an artist as a medium started to intrigue me. They also sparked an interest in the idea of sustained conversations – of conversations recorded over a period of time, perhaps over the course of many years; the Cabanne–Duchamp interviews took place over three

long sessions, for example. Sylvester's book of interviews with Francis Bacon was quite popular when I was a kid. I got a copy of this book when I was about fourteen and I thought it was actually really exciting that an art critic would talk to an artist again and again and create this unbelievably intense dialogue. These two books showed me the value of a long-term conversation series. If you sit down again and again in discussion with someone, things start to happen and be said that may be interesting for someone to read about.

Around 1993, when I began to collaborate with the *museum in progress* in Vienna, I would conduct conversations in television studios with artists – such as Vito Acconci and Felix Gonzalez-Torres. However, I soon found it more interesting to conduct conversations in a more informal setting, like over a coffee or in a taxi, and I thought it would be interesting to find a way to record the conversations without dragging people into a recording studio. From that moment onwards I did audio recordings, and then in the mid-1990s digital cameras came onto the market and I used them for about ten years. They have become a research method and the basis for my curatorial practice. I now have an archive of 2,000 filmed conversations, most of which I have only used as text transcriptions, and not yet presented as video. I haven't completely figured out yet what to use. Most get transcribed.

The more conversations I recorded and filmed, the more important they became to my curatorial practice. I realized these conversations functioned alongside my other work in a role not unlike the concept of crop rotation in agriculture. Curating large shows can be an all-encompassing task, with the added pressure of unmissable deadlines for all the work. That can lead to fatigue. Recording several unrelated conversations every week keeps me from burning out. And because they have

no particular deadline, they're a way of liberating time. Producing exhibitions represents the current crop of a curator's practice, while writing books is equivalent to preserving the harvest of the past. Conversations, meanwhile, are obviously archival, but they are also a form of creating fertile soil for future projects. For this reason, I began to ask everyone I interviewed a very future-oriented question: what is your unrealized project, your dream? The answers to this have spurred many new initiatives: from these conversations have come many new projects, in the form of both exhibitions and books.

At the same time, conversations are a way of archiving or preserving the past. One of the most important concepts underpinning my conversation practice came from the late historian Eric Hobsbawm, whom I interviewed several times starting in 2006. He spoke about history as a 'protest against forgetting'. But recollection is a contact zone between past, present and future. Memory is not a simple record of events but a dynamic process that always transforms what it dredges up from its depths, and the conversation has become my way to instigate such a process.

A further development occurred one day when I was with the artist Rosemarie Trockel in her studio in Cologne. Rosemarie told me she knew of my conversation project: 'You should really focus,' she said, 'on people whose eyes have seen the whole century! You should interview them all, you know, all the great artists and architects.' That day, Rosemarie and I made a list of who some of these ninety to one-hundred-year-old people might be, including the novelist Nathalie Sarraute, who was still alive then, the philosopher Paul Ricoeur and the architect Oscar Niemeyer. Ever since, I have continued to add to the list quite systematically. Often it is possible to get a picture of historical figures who we don't realize are still linked directly to

the living present. I interviewed Pierre Klossowski, who had been a friend of both Walter Benjamin and Georges Bataille. Through such conversations I have learned more about some cultural figures from the earlier twentieth century, as told by those with first-hand knowledge of the protagonists.

The conversation project is very incomplete, and there are many different branches – there's no master plan, it happens little by little. I also conducted conversations in which I would go with an artist to interview his or her mentor. For example, I started to go with Rem Koolhaas to see all the architects who had inspired him as a student: O. M. Ungers, Robert Venturi and Denise Scott Brown, and Philip Johnson. And as I began to do this, I started to realize that my own profession had its own pioneering figures whose valuable experience was in danger of being lost.

Curating, after all, produces ephemeral constellations with their own limited career span. There's relatively little literature on exhibitions, and there is also an extraordinary amnesia about exhibition history. When I started as a curator, we had to gather together various documents; there were no books, not even on figures as seminal as Alexander Dorner. Because of this extreme lack of documentation relating to exhibitions, I decided it was urgent to start recording an oral history. Johannes Cladders and Harald Szeemann talked a lot about their friend Willem Sandberg when he was director of the Stedelijk Museum in Amsterdam. I went to see Anne d'Harnoncourt, director of the Philadelphia Museum of Art. She and Walter Hopps both discussed at length early pioneers in American curating.

Most of curatorial history is oral history; it's very much a story that can only be *told* because it's not yet been *written*. The

curators I interviewed were themselves very familiar with the history of what came before them. Szeemann was totally into Sandberg, and Sandberg was completely familiar with Alexander Dorner. Through this ongoing series of interviews, I discovered some of the figures who continue to inspire my practice.

Pioneers

Over the years, I have come across a number of key practition-
ers in the development of exhibitions. Many of these figures
have been already mentioned in this book. Though what follows
is a subjective and by no means comprehensive list, these are
some of the pioneers I have come across, fragments from the
past that have become a toolbox for me.

Harry Graf Kessler

Harry Graf Kessler was a flamboyant and aristocratic figure
who played a major role in promoting modern art as a patron,
writer, publisher, museologist, politician and museum director.
His parents were a famously beautiful Irish countess and a
banker from Hamburg, and it was rumoured that he was
secretly the son of the German Kaiser. Like the critic Félix
Fénéon, Kessler pursued mobile strategies of display and medi-
ation. A junction-maker between artists, architects and writers,
he organized salons and also used exhibitions to put the art he
exhibited into a larger social and political context, as well as
pursuing publishing activities. Peripatetic from childhood, Kes-
sler was born in France in 1868 and grew up living in France,
England and Germany. He attended boarding school in England

and military school in Germany, before studying law, philoso-
phy and art at the universities of Bonn and Leipzig.

Kessler lived in Berlin in 1893, working on a literary journal,
PAN, that published the likes of Nietzsche and Verlaine, as well
as illustrations and design by visual artists. In 1903 he became
the director of the Weimar Museum of Arts and Crafts. While
there Kessler began to pursue publishing more seriously, found-
ing the Cranach Press and issuing books devoted to typography
and design. In a typical multidisciplinary project in 1913, he com-
missioned the theatre reformer Edward Gordon Craig to make
woodcuts for a Cranach edition of *Hamlet*, resulting in one of
the great works of twentieth-century printing. Kessler also
developed new exhibition concepts for the Weimar Museum.
Always a defender of newer forms of art, he was credited with
helping to introduce French Impressionism to Germany. He
also collaborated on ballets for Sergei Diaghilev, working with
Richard Strauss.

Kessler worked on a project for a new kind of theatre that
he called the *Mustertheatre*, again with Gordon Craig. The son
of the famous Shakespearean actress Ellen Terry, Gordon Craig
was the guiding force behind the New Stagecraft movement, in
which the theatre was seen as a unified art form. Kessler and
Gordon Craig planned to institute this vision of a new theatre
in collaboration with the Belgian architect Henry van de Velde,
whom they asked to design the building. In the end, plans for
the theatre failed, but it was a typical project of Kessler's: he
created an in-between situation that linked art, design and archi-
tecture, bringing people into a dialogue.

The final phase of Kessler's career moved beyond art: after
the First World War he turned his attention to politics. He kept
up his dizzying pace of activity in his new role, and became an
outspoken pacifist who argued against blind nationalism and

anti-Semitism. With Walther Rathenau, the Weimar Republic's half-Jewish foreign minister, he helped draft the peace treaty between Germany and Russia. After Rathenau was murdered in 1922, Kessler wrote his biography. He then became a diplomat in the Weimar Republic, serving as the first ambassador to the newly independent Poland.

Kessler often said that he felt he was a member of one great European community. He felt a strong impulse to get to know everyone who meant something from all walks of life, and he befriended many of the significant cultural and political figures of his time, from Albert Einstein to Auguste Rodin. W. H. Auden remarked that Kessler was probably the most cosmopolitan man who had ever lived. Kessler's practice was to meet a steady stream of culturally significant figures from all fields of activity, and link them to each other, like a global *salonière*. This is one of his great legacies.

Kessler also kept a journal for fifty-six years. Nine volumes of his diaries were published: with them Kessler has become a lens through which the first half of the twentieth century comes into focus. Like a seismograph, his diaries recorded the growing social and political crisis that led to the First World War, as well as the Impressionist and post-Impressionist movements in Paris. At the core of the diaries lie his dialogues with the world's leading artists, poets, writers and intellectuals – according to Laird Easton, the editor of the latest published volume, more than ten thousand names figure in them. Kessler lived and wrote the memoirs of his times. He developed a major aspect of the curator's practice – to bring together different worlds – and applied it to fields beyond.

Alexander Dorner

While studying at university in St Gallen, I was guided by a book I had found in a second-hand bookshop, *The Way Beyond 'Art'* by Alexander Dorner, and it became the most influential book on the potential of museums that I have read. Born in 1893, Dorner was director of the Hannover Museum from 1925 to 1937, the so-called 'laboratory years' of exhibition design. He defined the museum as an energy plant, a *Kraftwerk*, and he invited artists to develop new and dynamic displays for what he called the 'museum on the move'.

The avant-gardes of the early twentieth century had shifted the conventions of art away from the idea of the Romantic genius creating works in solitude – they understood that, as Duchamp said, the viewer does half of the work. Dorner brought this notion of art as a two-way participatory interaction into the museum and applied it to his methodologies of display. He asked artists themselves to design experimental new forms of display, including Herbert Bayer, Walter Gropius, Friedrich Kiesler, El Lissitzky, László Moholy-Nagy and others.

In 1927, Dorner invited El Lissitzky to make a room for the museum. Lissitzky responded with the *Kabinett der Abstrakten* (*Abstract Cabinet*), in which works in the collection could be moved around on sliding panels by the visitors – effectively, visitors could curate their own show. Dorner also commissioned Moholy-Nagy to design a room that would represent the present in art and design, a *Room of Our Time*. Moholy-Nagy responded by creating a plan for a room that incorporated photography, film, design, images of the latest architecture, slides of new theatre techniques, and a 'Light Machine' designed by Moholy-Nagy himself, which projected abstract patterns

onto the walls. Given the opportunity by Dorner, artists and designers were able to incorporate participation and interactivity not only into singular artworks, but into exhibition design as well.

Dorner had rethought the museum as an institution in a state of permanent transformation. He advocated a concept of art history that allowed for gaps, reversals and strange collisions – as the pragmatist philosopher John Dewey wrote in the foreword to Dorner's book, in his museum we are 'amidst a dynamic centre of profound transformations'. The museum, for Dorner, is not just a building but an oscillation between object and process: 'the processual idea has penetrated our system of certainties,' he writes. Museums should have multiple identities, he felt – they should stay on the move. Contrary to the stolid authoritarian role they are so often thought to play, museums should be risk-taking pioneers: they should act and not wait, they should be elastic in terms of display and in terms of physical presence, and they should be a locus for crossings between art and life.

Classic, traditional exhibitions emphasize order and stability. But in everyday life we see fluctuations and instability, a plethora of choices and limited predictability. As Dorner writes, 'We cannot understand the forces which are effective in the visual production of today if we don't examine other fields of life.' In the sciences, non-equilibrium physics has developed similar notions of 'unstable systems' and the dynamics of 'unstable environments'.

While operating in the pseudo-neutral spaces dating from the nineteenth century, prevalent at the time of his directorship in Hannover, Dorner managed to define the museum's functions in ways that are still relevant today. For Dorner, the museum was ultimately a laboratory. His book was my template, my toolbox, as I approached curating within an institution.

Hugo von Tschudi

Soon after being influenced by the example of Dorner and Kessler, I discovered the work of the museum curator and art historian Hugo von Tschudi, who also had roots in the eastern part of Switzerland. Born in Austria in 1851 and raised in Switzerland, Tschudi was at the forefront of the development of exhibitions as an international movement that could float free of the nationalistic context of the academies. Like so many figures in the history of exhibition-making, his biography is non-linear: he studied law in Vienna before devoting himself to curating within museums. In that role, he was to influence major museum collections decisively, moving them away from a narrowly national focus and towards acquiring the best cross section of works available to them.

In 1896, Tschudi became the director of Berlin's National Gallery, where he immediately purchased a set of new international paintings, including Manet's *In the Conservatory* (1879). This was the first time a painting by Manet had been bought by a museum; Tschudi's pioneering decision marked a turning point in the acceptance of what came to be known as 'modern art'. Celebrated for his eclectic yet prescient aesthetic judgements, Tschudi also acquired paintings by Bonnard, Monet, Degas and Cézanne. It's hard to remember today, when Impressionist painting plays a sanctified role in our culture, that these artists were seen as scandalously inappropriate in a museum collection. By the late nineteenth century the museum collection was already understood as an allegory for national greatness. Not only was Tschudi opening up the collection to artists of other nations, he was also proposing that a new and widely distrusted form of art, modernism, be

accepted into the canon. It was a double affront to accepted good taste.

Protests over 'degenerate' modern art were common in the pre-First World War Germany in which Tschudi worked. A group of 140 German artists put their signatures to a document objecting to the importation of works by foreign artists. By this point they had come to accept the importance of Manet, but Van Gogh, Picasso and Matisse remained inadmissible in their view. Such scenes of protest seem laughable today. But these protests also revealed and further emphasized the importance of the museum and its curator: rather than as an individual with a particular aesthetic, Tschudi was attacked as the steward of a nation's understanding of what is valuable. He was fired from Berlin's National Gallery in 1908 by the emperor, who claimed his management of the budget had been inappropriate. Tschudi's insistence on globalizing national collections, however, was probably also to blame.

Although he championed the latest developments in art, Tschudi did not neglect historical painting. He believed there was a beneficial relationship between Manet and masters such as Goya and Velázquez. In his view, the Impressionists were working on an aspect of painting that the Old Masters had not yet tackled: the horizontal picture plane. Where older epochs in European painting had developed the art of depicting three-dimensional space through a two-dimensional picture-plane perspective, the Impressionists and post-Impressionists were investigating the relationship between three-dimensional space and the mostly flat plane of canvas on which paint produced this illusion. Tschudi was perhaps the earliest curator to focus on this aspect of artistic innovation, and the institutions for which he worked ended up with vastly more valuable and influential collections because of his instinctive eye.

Brian O'Doherty's *Artforum* essays made this connection as well, showing how Monet and others played with visual effects that made use of the tricks of the eye. Tschudi, of course, had championed this view through his selections nearly one hundred years before, and had lately come to be appreciated for just this. As a review in the *Wall Street Journal* of a show of his acquisitions (titled 'The Battle over Modernist Art') put it:

> . . . in the end, Tschudi won. 'Degenerate' no more, the paintings in this show give a fresh view of Impressionism through one man's eyes. And his legacy is evident beyond the show, in the museums he once worked for. Without Tschudi, the collection of Munich's Neue Pinakothek would consist solely of 19th-century, largely bland German art – making less of a case for German superiority than its Cezannes, Manets and Gauguins do today.

Willem Sandberg

I once travelled through the hills of Appenzell in Switzerland with Harald Szeemann. During the trip he told me to study his hero, Willem Sandberg. Born in 1897, Sandberg was one of the great museum innovators of the twentieth century, personalizing and creating a stylistic identity for the Stedelijk Museum in Amsterdam, where he was appointed curator (1938) and then became director (1945–62). Sandberg left a mark on every single aspect of the museum: renovating its interior, adding a restaurant and children's centre, and transforming the collection. A largely self-taught graphic designer, he also designed the catalogues for his exhibitions, developing a highly recognizable graphic sensibility of lowercase

letters; text used pictorially; bold reds, blues and yellows; and torn edges.

During the Second World War, Sandberg was part of an underground Resistance group that in 1943 burned down the Amsterdam Municipal Office of Records to stymie the Nazi occupation. For the rest of the war he was marked for death by firing squad – had he been caught. During the war, Sandberg worked on his graphic design, producing the *Experimenta typographia*, a collection of eighteen handmade books composed poetically of asymmetrical, multicoloured typesetting on pages with torn edges. He also used his graphic-design skills to forge identity papers for fellow members of the Resistance.

Sandberg became director of the Stedelijk Museum at the end of the war, maintaining this position until his retirement in 1962. In addition to his duties as a director and curator, he designed hundreds of catalogues and posters. Not content with traditional definitions of high art, he incorporated graphic and industrial forms into the Stedelijk's collection. Politically, he remained a controversial figure who was denied a visa to visit the United States during the period of anti-Communist hysteria in the 1950s. Like most of the great museum directors of the twentieth century, Sandberg successfully encouraged a much more diverse public to visit the institution. Attendance during his tenure doubled.

The Stedelijk was a museum with a limited budget, so Sandberg organized many small shows rather than major retrospectives with lavish catalogues. In 1957, while the Rijksmuseum hosted a Rembrandt exhibition, Sandberg showed Picasso's *Guernica*, calling it the 'Nightwatch' (after the Rembrandt canvas) of the twentieth century – taking advantage of the larger institution to bring the public into contact with a contemporary masterwork. He put on large shows as well, however, such as *Art Since 1950* for the Seattle World's Fair in 1962. His 1961 show, *Die Pioniers*, was

one of the first to travel amongst various museums. In the 1950s he built a new wing of the Stedelijk to his own specifications: open space, natural light from the sides, simple decor without embellishment. He also edited journals, served on the committees and organizing bodies of many other institutions, and was engaged in Dutch programming for the arts. Sandberg was also a vegetarian who fasted regularly, did not drive and lived in a simple apartment. He expanded design, typography, and the role of museums and museum directorship alike.

Walter Hopps

Bice Curiger, the editor of *Parkett*, was one of my early mentors. When I was 17, she returned from a trip to New York with an article for me about a curator she said I should know, Walter Hopps. Hopps' biography displays an extraordinary range. Born in 1932, he showed early signs of his penchant for organization by founding a photographic society in high school. In the 1940s he was a keen promoter of jazz, during one of its great periods of innovation. While attending UCLA in southern California, he ran a gallery called Syndell Studio, which served as an incubator or a laboratory for his curatorial practice. It received few visitors and very few reviews in the press, but through the gallery he was able to meet many people – the lifeblood of any curator's metabolism.

From his earliest days as an exhibition-maker, Hopps was interested in bringing new artists and new ideas to the public's attention. While running the tiny Syndell Studio, he also organized a show called *Action 1*, a presentation of the works of Californian expressionist painters in the merry-go-round building of an amusement park on Santa Monica pier. Such artists had received very little critical attention at a time when the art

world was largely restricted to Europe and New York, so Hopps took it upon himself to rectify this. The show attracted, in his words, 'the most totally inclusive mix of people – Mom, Dad, and the kids, and Neal Cassady, and other strange characters, and the patrons of a transvestite bar nearby'. After leaving UCLA, Hopps soon formed the Ferus Gallery in 1957, and five years later he became director of the Pasadena Museum of Art.

At Pasadena, Hopps also made significant strides in the opposite direction, exposing southern California, and the United States as a whole, to important artists from Europe. He organized the first American retrospective of Kurt Schwitters. His exhibition *New Paintings of Common Objects* was the first museum overview of American Pop art. Perhaps his most legendary show in Pasadena was in 1963 – Marcel Duchamp's first one-man museum show. Duchamp had an enduring influence on Hopps, through his focus on the exhibition as a totality, rather than on individual works. In the wake of their collaboration, Hopps formed one cardinal curatorial rule: in the organization of exhibitions, the works must not stand in the way.

Hopps believed that curating required obsessive knowledge of an artist's oeuvre, comparing the task to a conductor who must know a composer's entire body of work intimately in order to conduct a particular symphony. His obsessiveness came with a mercurial nature and a deep eccentricity about working hours: he often arrived at the office in the evening and worked through the night. He was not punctual and would sometimes go missing for days on end. In Washington, where he went from Pasadena to become director of the Washington Gallery of Modern Art in 1967 and then the Corcoran Gallery in 1970, bemused employees had badges made saying 'Walter Hopps will be here in 20 Minutes'.

By putting Los Angeles on contemporary art's map, Hopps

changed the contours of the art world, and he continued expanding boundaries after leaving California. In 1975 he curated perhaps the ultimate democratic exhibition, *Thirty-Six Hours*, for the Museum of Temporary Art in Washington. He invited the public to bring their own works, the only requirement being that they fit through the door. Personally greeting each artist, Hopps installed their work on the spot, eventually accommo-dating more than four hundred works. He invited musicians to perform on the opening night, in part for a strategic purpose: he used their contacts amongst disc jockeys to advertise the show on late-night radio, believing that artists were likely to be up working in their studios and would hear about the show. His most ambitious unrealized ambition, with Alanna Heiss, was to install 100,000 images in PS1, the contemporary art centre in New York, reasoning 'people can take in presentations of art that are almost as vast as nature'.

René d'Harnoncourt

René d'Harnoncourt, who was born in 1901 in Austria with an aristocratic title but without inherited wealth, began his career in Mexico, organizing artisans and craftsmen in the production and sale of folk art. Out of this experience he began to organize large-scale shows of Mexican art that travelled to museums throughout the United States. Even as d'Harnoncourt began curating, he continued to work directly with the people whose art he exhibited, in a respectful form of anthropological field-work; eventually, he became one of the most influential US museum directors of the twentieth century, at the Museum of Modern Art in New York (1949–68).

D'Harnoncourt began at MoMA, working for Alfred Barr,

its legendary first director. Barr, who was strongly influenced by Alexander Dorner's work, promoted modernism in painting, sculpture and the newer, related fields of photography, film, typography and graphic design. He also developed what came to be known as the 'white cube' style of display, which favoured rectangular, neutral spaces with works placed far from each other and at the height of the viewer's eye. Works were meant to be encountered alone, rather than part of an ensemble, bestowing a new power on the single artwork. To Barr's modernist aesthetics, however, d'Harnoncourt added a pioneering understanding of the globality of art.

In the first half of the twentieth century it was the norm for Western art museums to present modern Western art and society as the pinnacle of cultural evolution. D'Harnoncourt sought to complicate that picture. For his MoMA show *Indian Art of the United States*, he brought Native American sand-painters to the museum to produce works that were destroyed just before completion, as per traditional practice. The museum staff were instructed to treat them with care and never to disturb them. When he displayed Navajo shawls, d'Harnoncourt treated them on a par with contemporary Western art, placing them on abstract cylinders, rather than presenting them as mannequins dressed like Indians, which would have been expected.

In the early 'laboratory years' of the Museum of Modern Art, d'Harnoncourt pioneered a new style of exhibiting artworks based around their common affinities, rather than their particular place in history. This modern idea lay behind his seminal show, *Timeless Aspects of Modern Art*, held in 1948–9. D'Harnoncourt included works ranging from prehistoric carvings to Sung dynasty paintings to Picasso; he began the exhibition with a timeline of the last 75,000 years and a map of the world on which the artworks' places of provenance were marked. However, he

displayed the works from across human history spotlit in darkened galleries, emphasizing their individual character even as he showed how art from all periods used very modern techniques, such as exaggeration, distortion and abstraction. Where previous museum directors had expanded the appreciation of art across Western national boundaries, d'Harnoncourt emphasized its influence across the entire globe and throughout its history. His career, however, was cut short when he was killed by a drunk driver in 1968.

D'Harnoncourt's daughter Anne, a curator and later director of the Philadelphia Museum of Art, was a pioneering curator as well. She also told me much of what I know about her father's career. Anne d'Harnoncourt became a curator in Philadelphia soon after it acquired the most important collection of Marcel Duchamp's works in the world, from his benefactors the Arensbergs. She went on to install the great unseen work he left behind, *Étants Données*, in Philadelphia, as well as organizing a major retrospective of Duchamp's work that influenced countless artists. For that alone she ranks among the more important American curatorial figures. Anne d'Harnoncourt was director of the Philadelphia Museum from 1982 – she was the first woman to hold that position at a major American museum – until her death in 2008.

Pontus Hultén

As the founding director of several museums, including the Georges Pompidou Centre in Paris and the Museum of Contemporary Art in Los Angeles, Pontus Hultén's innovative exhibitions expanded the scope of curatorial practice and redefined the function of the museum. Born in 1924, during his thirteen-year tenure as director of the Moderna Museet

(1960–73) Hultén transformed his museum into one of the leading institutions for contemporary art – in the process facilitating Stockholm's emergence as a principal player in the art world of the 1960s. Hultén combined various art forms – theatre, dance, painting, film and so on, under one roof, reasoning that 'artists like Duchamp and Max Ernst had made films, written a lot, and done theater, and it seemed completely natural to me to mirror this interdisciplinary aspect of their work in museum shows of any number of artists . . .'

Looking at the program of exhibitions that Hultén undertook during the 1950s and 1960s, it is very clear that his curating, even at the beginning of his practice, takes up the standard of Alexander Dorner's battle cry earlier in the century, namely to dynamize the museum; the strange collisions and reversals that Dorner's vision of art history advocated are sharply evident throughout Hultén's trajectory. Dorner's notion that the museum should aspire to be a *Kraftwerk*, or power station, is echoed in Hultén's view that the museum should be an open and elastic space; one that does not limit itself solely to the display of paintings and sculptures, but provides a site for a myriad of public activities: film series, lectures, concerts and debates.

Hultén was both intellectually and practically invested in what, at the time, was a still largely latent movement towards an increasingly international, cosmopolitan art community. In the 1960s he and Niki de St Phalle organized *She*, a startling exhibition housed in a large cathedral in the form of a supine woman that viewers could walk into, the entry being between her legs. During his time at the Moderna Museet, Hultén was also instrumental in enabling artistic exchanges to take place between Stockholm and New York. In 1962 his show *4 Americans* introduced the work of Pop artists such as Robert Rauschenberg and Jasper Johns to the still largely insular European art

world; later, he installed one of the very first European surveys of American Pop art, and was responsible for bringing together the first international survey of Andy Warhol in 1968.

In 1968, Hultén was invited by Alfred Barr to organize an exhibition of kinetic art at the Museum of Modern Art in New York, but, as he told me in one of our meetings in his next-door apartment on rue Beaubourg, he thought the subject too vast. Hultén instead proposed a more thematic and critical exhibit, one that would explore both the approaching end of the mechanical age and the role of the machine in art, industrial design and photography. The resulting show, called 'The Machine as Seen at the End of the Mechanical Age', covered vast historical ground. Beginning with Leonardo da Vinci's sketches of flying machines and ending with contemporary pieces by Nam June Paik and Jean Tinguely, the exhibit comprised over 200 constructions, sculptures, paintings and collages, as well as a film programme.

In 1973, Hultén left Stockholm to help found the Centre Georges Pompidou in Paris, which opened in 1977. Hultén's inaugural project in the newly erected space was *Paris-New York*, the first of four large-scale exhibitions that examined the making of art's history in the cultural capitals of the twentieth century. *Paris-New York*, *Paris-Berlin*, *Paris-Moscow* and *Paris-Paris* included not only art objects ranging from Constructivist to Pop, but posters, films, documentation and reconstructions of art spaces such as Gertrude Stein's famous Parisian salon, Piet Mondrian's New York studio and Peggy Guggenheim's short-lived but highly influential New York gallery, Art of This Century. While Hultén's MoMA show is widely considered one of the art world's major interdisciplinary exhibitions of its time, *Paris-New York* came to be heralded for its presentation of an array of objects and concepts never before seen within the narrowly defined fields of traditional art history and museum practice.

Night Trains and Other Rituals

One cold December morning in the year 1989, I was travelling from Rome to Venice. I had been visiting the artist Cy Twombly and had left the capital by train the evening before. I had spent the night awake, ruminating on my visit with Twombly. He was steeped in the history of poetry and a lot of his paintings make allusions to, are inspired by or are responses to poems: *Leda and the Swan*, his sprawling, swooping vision of W. B. Yeats' poem of the same title, is just one example. Twombly was always talking about his reading of Rumi, Keats, Pound, Rilke and others. He was also deeply inspired by the poets of antiquity: Catullus, Sappho and Homer. Twombly had advised me to connect art and poetry. All the great twentieth-century avant-garde movements had one thing in common: close ties between art and poetry: Dada and Surrealism, and so on. Yet in our time, dialogues between art and music, or art and architecture, are much more frequent than dialogues with poetry. Twombly told me something was missing.

I was to repeat that morning experience in Zurich many times: during my years at university, I took night trains all around Europe. Nights spent on the train became my think tank. It was also, of course, an economical way to travel: like many European students, I had an InterRail pass. Night trains

also saved time. One could leave a city late at night, and arrive in the next one early in the morning. Trains were my hotels. One city, one day. On my travels during those years I visited an ever-expanding group of artists, ranging further with chains of train trips, and driving my old Volvo station wagon for shorter distances. This being the pre-mobile-phone era, night-train rides were also a kind of refuge from the world. I could reflect on what I had seen that day, make notes and have conversations. Soaking up ideas like a sponge each day in the studios of artists I admired, I would process their work in my mind in the quiet of the train.

I had strong ties with artists, and a sense of ease with them, so it was natural to pursue my obsession with art and artists, even if I had yet to curate an exhibition. It was a period of study and observation.

Night trains taught me to sleep when I could. On a long train or bus journey you learn to rest when you can, despite the lack of comfort. I also began to experiment with different ways of sleeping. For instance, I had read about Leonardo da Vinci's method, which involved sleeping fifteen minutes every two hours. I tried it. Honoré de Balzac would drink large amounts of coffee (to fuel his ceaseless creativity he would reportedly drink up to fifty cups per day), including just before falling asleep to limit the length of time spent unconscious. However, he died aged fifty-one, possibly from caffeine poisoning, and so I eventually curbed this tendency. The idea behind these unconventional procedures was not just to reduce the amount of sleep to the minimum required for an active and creative existence. They were also attempts to try out alternative ways of organizing daily life, alternative daily rituals. The attraction of these methods to me has always been to erase the structural

separation between work and recreation that organizes conventional living. The night train was a way to get from city to city, but also a travelling laboratory for testing such practices.

Trains were also the subject of many of my conversations with the architect and urbanist Cedric Price. In the mid-1960s, Price had devised an ambitious plan he called the 'Potteries Thinkbelt' to use industrial rail lines to renew Staffordshire, an industrial area in the Midlands, south of Manchester. Because of the many ceramics factories that had operated there since the 1700s, the region had accrued the name 'The Potteries'. Josiah Wedgwood, Josiah Spode and the Mason family had all started out in the region. By the time of Price's project, the area had begun to decay. It still had an extensive train network from the days in which trains were the main way to get freight from factory to market. The centrepiece of his plan was to rehabilitate this network, and in the process Price designed a mobile university system – one of movable classrooms, laboratories and research centres that could move along the train lines. His system was highly suited to the study of the area's factories. Railways transform an area into a network of nodes; Price simply planned to utilize this transformation. Unfortunately, his grand project never saw the light of day. When I eventually began to learn about architecture and discovered this plan, it made perfect sense to me from my days of constant train travel. Europe, for me, was a kind of 'Thinkbelt', all linked by the rail.

I remember a school trip to Paris around this time. I had seen the artist Christian Boltanski's work in Switzerland, and was aware that he lived and worked in Malakoff, 5 kilometres southwest of Paris. I arranged to visit him and the artist Annette Messager, while my schoolmates were trudging around the city. I spent a life-changing afternoon with them. Boltanski's studio

was full of used clothes and biscuit tins. At this stage, my desire to be a curator had solidified, but I was still generally unsure of how I could be useful to art. Boltanski was very clear on one point that has become one of my guiding principles: exhibitions, he said, should always invent a new rule of the game. People only remember exhibitions that invent a new display feature, he pointed out, and so that should be an ambition of each new exhibition.

Boltanski was also close to the great exhibition-maker Harald Szeemann. He told me that Szeemann was not only curating shows at major museums like the Kunsthaus in Zurich but also worked all over the world. The Kunsthaus channelled all the research generated by his constant travelling. The idea of being an independent/dependent curator appealed to me. The work of a free curator, who always works in different institutions and different cities, has its limits, because there is no connection to a specific context, and there is no continuous dialogue – so the dichotomy of the permanent/not permanent curator was very important for me. With Boltanski, I first started to conceptualize this ordered/disordered model of working as a curator, taking Szeemann as an exemplar.

The third significant direction in which Boltanski pointed me was back towards literature. He introduced me to Oulipo, short for *Ouvroir de littérature potentielle* ('workshop of potential literature'), the avant-garde literary group that functioned as a research laboratory for the invention of new rules for producing literature. Founded by Raymond Queneau, Oulipo sought to use constraints, transpositions and game structures to generate new works. Many of the works of Oulipo authors contain nearly endless accumulations of lists, which for me connected directly to the endless Hans Krüsi lists of my childhood.

Boltanski also recommended particularly that I read Georges

Perec, who I discovered had some fascinating things to say about the relation between order and disorder. In his essay collection *Penser/Classer* (*Think/Classify*), Perec writes that order entails disorder and vice versa. He also speaks of the depressing aspect of all systems of absolute order that do not admit chance, differences, diversity. In other words, he claims that order is always ephemeral, that it can become disorder again the next day: 'My problem with classifications is, that they don't last; as soon as I have finished a certain order, it is already lapsed. Like everyone else I sometimes have a mania of ordering things. But because of the abundance of things to be ordered and the near impossibility of ordering them into a satisfying classification, I never come to an end. I have to stop with a provisory and vague order, which seldom is more effective than the previous disorder.'

The Kitchen

During my time at high school and university in Kreuzlingen and St Gallen, I travelled around Europe looking at art, visiting artists, studios, galleries and museums. I knew that what I wanted to do in life was to work with artists, but I had yet to produce anything. I was searching for a way to make a contribution. What, in this art system, could be a first step, and above all, how could I be useful to artists? I began to think about all the innovative, large-scale museum shows I had seen and whether it was really possible to do something new, combining all the networks I had been enmeshed in, the entire European Thinkbelt. One conviction I had was that it could be interesting to do something smaller, after the gigantism of some of the 1980s art scene which seemed unsustainable after the crash of 1987.

Dependency on endless growth, as the end of each cyclical bull market always teaches us, is unrealistic. I studied political economy with a professor named H. C. Binswanger, who directed the University of St Gallen's Institute for Economics and Ecology. Binswanger was examining the historical relationship of economics and alchemy, which he made as interesting as it (at first) sounds outlandish. His goal was to investigate the similarities and differences between aesthetic and economic value, most famously in a book he later published called *Money*

and Magic (1994). At the core of modern economics, Binswanger believed, is the concept of unlimited, eternal growth; he showed how this brash concept was inherited from the medieval discourse of alchemy, the search for a process that could turn lead into gold.

In his childhood, Binswanger had been fascinated by the Faust legend. During his studies he discovered that the invention of paper money in Goethe's *Faust* was inspired by the story of the Scottish economist John Law, who in 1716 was the first man to establish a French bank issuing paper money. Even more strikingly, the Duke of Orleans got rid of all his alchemists after Law's innovation, because he realized that the availability of paper money was more powerful than all attempts to turn lead into gold. In *Money and Magic*, Binswanger traces the deep association between paper money, alchemy and the concept of eternal growth that underlies modern economics.

Binswanger also connected the economy and art in a novel way. Art, he points out, is based on imagination and is part of the economy. But the process of money creation by a bank is connected to imagination, because the money is printed as a countervalue for something that doesn't yet exist. So the invention of paper money is based on imagination, or a prospective sense of bringing into being something that has yet to exist. A company imagines producing a good and needs money to realize this, so it takes out a loan from a bank. If the product is sold, the 'imaginary' money that was created in the beginning has a countervalue in real products. In classical economic theory, this process can be continued endlessly. Binswanger recognizes that this endless growth exerts a quasi-magical fascination.

In his book Binswanger pointed out that the moderation of growth has become a global necessity: he produces a way of thinking about the problems of rampant capitalist growth.

Binswanger encouraged me to question the mainstream theory of economics, and to recognize how it differs from the real economy. The wisdom of his work is that he recognized early on that endless growth is unsustainable, both in human and planetary terms, but instead of rejecting the market wholesale, he suggests ways to moderate its demands. Thus the market does not have to disappear or be replaced, but can be understood as something to be manipulated for human purposes, rather than obeyed.

Another way of interpreting Binswanger's ideas is as follows: for most of human history a fundamental problem has been the scarcity of material goods and resources, and so we have become ever more efficient in our methods of production, and created rituals to enshrine the importance of objects in our culture. Less than a century ago, human beings through their rapacious industry made a world-changing transition: we now inhabit a world in which the overproduction of goods, rather than their scarcity, is one of our most fundamental problems. Yet our economy's growth functions by inciting us to produce more and more with each passing year. In turn, we require cultural forms to enable us to sort through the glut, and our rituals are once again directed towards the immaterial, towards quality and not quantity. Perhaps that is a reason for the shift in our values, from producing objects to selecting amongst those that already exist.

During the days I attended Binswanger's lectures, I thought about the kinds of exhibition I could make. At the time, two shows, both of them in a domestic environment, were on my mind. In 1974, Harald Szeemann had created a small exhibition about his grandfather, who was a hairdresser, in his apartment in Bern. The second was in 1986 in Belgium, where curator Jan Hoet had hosted a show called *Chambres d'Amis* (*Rooms of*

Friends) in a very intimate, non-institutional environment: he commissioned more than fifty artists to make works for an equal number of private apartments and homes around Ghent. It was a way of making a sprawling exhibition that also took visitors on a domestic tour of the city. And then both Fischli and Weiss and Christian Boltanski suggested to me that perhaps I was looking too hard, that the solution could be in my own flat, as with the Edgar Allan Poe story 'The Purloined Letter'. And we began to think, and an answer occurred to us: my kitchen.

The answer was pragmatic. I didn't have access to an exhibition space in a gallery or a museum, of course, but I did rent an old flat in St Gallen. I never cooked. I never even made tea or coffee because I always ate out. The kitchen was just another space where I kept stacks of books and papers. This was exactly the feature that Fischli, Weiss and Boltanski had independently noticed. The non-utility of my kitchen could be transformed into its utility for art. To do a show there would mix art and life, naturally. The idea took shape very quickly. Perhaps because the show's concept was pithy and fitting for me, artists immediately responded to it. Fischli and Weiss thought it would be great to transform my non-kitchen into a functional kitchen. Then the exhibition would actually produce reality, they joked. Boltanski, meanwhile, liked the thought of a hidden exhibit in the kitchen. As art was conspicuous for its moments of high visibility in the late 1980s, he was attracted to the idea of something more intimate.

I embraced both ideas. Boltanski created a very hidden exhibit: he installed a projection of a candle, visible only through the vertical crack between the cabinet doors under the sink. The candle was like a small miracle where you would normally find the garbage or cleaning supplies. Above the sink was a big cupboard, and here Fischli and Weiss installed a sort of everyday

altar, using oversized, commercially packaged food from a restaurant supply store. Everything was giant: a five-kilogram bag of noodles, five litres of ketchup, canned vegetables, huge bottles of sauces and condiments. The installation had an *Alice in Wonderland* sense about it. It produced a sense of wonder by giving an adult a child's perspective. All of a sudden reality was, for the adults who beheld this oversized display, almost like it is for children. The only item we ever opened was a chocolate pudding. The rest of the pieces were kept intact as readymades, and eventually returned to the artists, who kept them in their basements – until they began to rot.

Hans-Peter Feldmann decided to make an exhibition within the exhibition in my refrigerator. He found six eggs made out of dark marble, which he placed in the egg rack in the fridge door. And then he placed a board with small feathers on it on the top shelf, setting up a charming visual rhyme in and amongst the few jars and cans that had somehow found their way into even my most under-utilized fridge. Frédéric Bruly Bouabré produced a kitchen drawing with a rose, a cup of coffee and a sliced fish. Richard Wentworth placed a square mirrored plate on top of cans of food. No one attempted to make a spectacular intervention – instead they preserved the function of the kitchen, while subtly adding to it.

Many features of the kitchen show mark my work as a curator to this day. For instance, artists shared in all tasks relating to my exhibitions, not just their individual pieces: Richard Wentworth named the kitchen show *World Soup*, while Fischli and Weiss took the exhibition photographs. Secondly, I continue to curate exhibitions in people's houses, which brings a different focus and a special intimacy. To give a very different example, I created an exhibition at the neoclassical architect Sir John Soane's house in 1999.

Numerous are the posthumous museums and memorials devoted exclusively to one artist, architect or author and designed to preserve or artificially reconstruct the namesake's original working or living conditions. Much rarer are the museums conceived by artists in their lifetimes as a *Gesamtkunstwerk* and preserved as such. Sir John Soane's Museum is a case in point. In 1833, four years before he died, Soane established his house as a museum and negotiated for an Act of Parliament to ensure its preservation after his death. The house is a complex accretion of hallways, windows, hangings, plinths, mirrors and innumerable objects, with unexpected views around every corner. Soane's holdings fall into four main categories: antique fragments, paintings from Canaletto to Hogarth and Turner, architectural drawings (such as Piranesi's), and Soane's own work in the form of architectural models and drawings.

The artist Cerith Wyn Evans once told me: 'I was always very stimulated and inspired by the relationships, the interstices in Sir John Soane's Museum, the conversations that are happening between various narratives, various objects and these extraordinary vistas that you come upon by accident and then you catch a reflection of yourself. It is an incredibly complex, stimulating place, and no one visit is ever the same as the next.' After a while, the idea of an exhibition began to take shape, and, in the course of the following two years, it crystallized in conversation with Margaret Richardson, the Curator of the Museum.

Although Sir John Soane's Museum has regular opening hours and attracts some 90,000 visitors a year, it has acquired a reputation primarily by word of mouth. The paradox of a well-guarded and yet public secret as well as the permanent pull between visibility and invisibility are the considerations that motivate Cerith Wyn Evans, whose intervention on the staircase is almost invisible. The work slides into the existing context

as it subtly changes the sound of the bells. Steve McQueen created a sound montage that revealed itself only at second glance.

To bring the various elements of the exhibition into a cohesive whole, each of the artists contributed to the greater picture: Richard Hamilton designed the poster, and each artist created a postcard that was on sale in the museum. The works on view in the exhibition were numbered but not labelled, in keeping with the way Soane displayed his collection. Each visitor was given a foldout leaflet, conceived by Cerith Wyn Evans, with plans by Christopher H. Woodward. There were no didactic panels or sound guides, and visitors moved where they wished through the rooms, encountering unexpected works of art in unexpected places. Cedric Price created symbols for the show and gave a lecture in the old kitchen entitled 'Time and Food', and Douglas Gordon created the title of the exhibition: *Retrace Your Steps: Remember Tomorrow*. Like the works in *World Soup*, the works in *Retrace Your Steps* had a sense of playfulness, and both shows were self-organized – instead of beginning with a master concept or plan, they grew organically. Exhibitions should develop a life of their own, more like a conversation between curator and artist than an arrangement of their work to suit a pre-existing idea.

The experience with Cerith Wyn Evans at Sir John Soane's Museum led to an ongoing series of house museums. Next came an exhibition with Pedro Reyes at the Casa Barragán, the architect Luis Barragán's home in Mexico City. After that I curated an exhibition at the poet Federico García Lorca's house in Granada, produced by Isabela Mora, followed by another show produced by Isabela Mora at the Lina Bo Bardi house in Sao Paolo, Brazil.

Robert Walser and Gerhard Richter

When I was a student I had the idea of creating museums for two of my heroes: Sergei Diaghilev and Robert Walser; the former remained unrealized but I was able to achieve the latter. Walser, born in 1878 in Switzerland, is an important modernist, an influence on Walter Benjamin and Robert Musil. Franz Kafka called him his favourite writer. His short stories and novels narrate the experiences of lonely clerks, assistants and other quasi-anonymous men. Walser's narratives lack traditional plots; they reveal fragments and details no longer bound to a fixed point of view. His practice was based on walking. Susan Sontag wrote, 'Walser's life illustrates the restlessness of one kind of depressive temperament: he had the depressive's fascination with stasis, and with the way time distends, is consumed, and spent much of his life obsessively turning time into space: his walks.'

Walser had many different periods in his short writing life. In 1905 he went to Berlin, where his brother was a painter. And after this first exile, he then had a fictitious exile, in which he imagined in minute detail what it would be like to live in Paris. Like Joseph Cornell, who never went on a grand tour, Walser went on an imaginary grand tour. But soon after that he suffered a breakdown and in 1929 was committed to a sanatorium.

Anticipating Oulipo, in the clinic Walser worked under self-imposed constraints, such as only using one page for a story or a chapter of a novel (in tiny script), never numbering his pages. He went into a kind of inner exile and began writing in minuscule letters, microscripts, which became smaller and smaller; it was even thought he had developed a secret form of coded writing. Walser wrote his microscripts in the privacy of his attic, and he told nobody about them. (Recently, Werner Morlang has deciphered these microscopic writings, a task that took him more than a decade, and showed that Walser's microscript was not a secret code: just really, really small.)

Towards the end of his life, Walser was transferred to a different sanatorium against his will. Thereafter, he never wrote again. Instead, he went on endless walks. Karl Seelig, a Swiss literary scholar, accompanied him on these walks, and wrote *Wanderungen mit Robert Walser*. It's an extraordinary record of the time after Walser stopped writing, and reading. On these walks, Walser and Seelig would occasionally stop for a drink at the Hotel Krone in Gais.

Somehow Walser became known to many artists, who were interested in his practice. They often talked to me about him. And so in 1992 I created the Robert Walser Museum, which was really just a vitrine in the Hotel Krone restaurant. The midpoint of these walks seemed the right place to put the museum. The landscape is the foothills of the Alps. The whole business of the restaurant functioned as usual during the exhibition; only the one movable vitrine had been added. My idea was to establish a non-monumental, modest contemporary trace of Robert Walser in the area where he spent the last twenty-three years of his life. The exhibition was a supplement to – maybe also a distortion of – the daily life of this restaurant in Gais. The artists

in our exhibition always drew connections to it. Dominique Gonzalez-Foerster, for instance, worked on Walser's last walk in the snow.

It was Gonzalez-Foerster's first show in Switzerland, also my own first collaboration with her, and one of the first projects produced for the Robert Walser Museum. She positioned the vitrine in the entrance to the hotel, setting it upon a small white rug, and she placed within it a book of photocopied images of people in snowy surroundings. The intimacy of the work was matched by its initial reception during Easter of 1993, at an opening attended by only around ten people. In many different ways, the installation created a subtle interruption in the fabric of reality for this restricted audience and for this short span of time. Gonzalez-Foerster's work therefore set the tone for the museum's subsequent exhibitions. While their traditional format puts the highly static human-to-object relation centre stage, she showed that, today, the object-exhibition may be cast in dialogue with, or in opposition to, a focus on shared experiences between individuals.

For Gonzalez-Foerster, snow is a 'reverse obsession' that contrasts with her predominant theme of tropicalization – how cultural activity, such as modernism, is reframed in warmer climes – and as she revealed to me some fifteen years after the installation was produced:

I feel this snow scene is just as important as tropicalization, in fact. It's really the first time I've been so obsessed with snow. Perhaps that's because it was just a fact of life when I was growing up, just as it must have been for you. But now I've discovered its beauty and the incredible excitement that can accompany it. It also makes me think of Robert Walser and his relationship to snow – his last winter walk into the snowy landscape.

On Christmas Day 1956, Walser had died of a heart attack in a snowy field near the mental asylum where he had been committed decades earlier. On the occasion of the opening of Gonzalez-Foerster's installation it began to snow outside. Another interesting thing happened during the opening: the grandson of Robert Walser arrived. But this was impossible, because he didn't have a grandson. The person was a businessman from Turin, who told us that he was conducting biographical research on his grandfather. We invited him to dinner and then it came to light that he was the grandson of another person called Robert Walser, who also came from this region and was the inventor of a certain ballpoint pen.

Of all the different relations of the visual arts, I think that the relation to literature has been neglected in recent years. The 'bridges' between art and music, art and fashion, art and architecture, and so on, are stronger than ever, and I have always worked on these relationships. But the whole 'bridge' to literature is missing, and I continue to try to work on this. For me it has always had to do with the dialogue between Robert Walser and the fine arts, and with the larger relationship between art and elsewhere.

At the same time as I was working on the Walser Museum, I organized my first exhibition with Gerhard Richter – in 1992 in the Nietzsche-Haus Sils Maria. I had met Richter for the first time at his opening at the Kunsthalle Berlin in 1985, when I was 17, after which I began a series of formative visits to him in Cologne. I often met him in Sils Maria and we sometimes went to the Nietzsche-Haus, the house where the great philosopher stayed over several summers and wrote parts of *Also Sprach Zarathustra*. Richter would take a lot of photographs in Sils Maria, especially of the Alps that tower above the town, and then paint

on them. And so we had the idea of organizing an exhibition of these overpainted photographs at the Nietzsche-Haus.

This was also the first time that Richter showed overpainted photographs as autonomous works. The photographs were taken in the area around the exhibition venue, the Alpine landscape of the Engadine, and with their small formats they fitted very discreetly into the existing interior of the Nietzsche-Haus. A simple way to describe Richter's Sils overpainted photographs would be to say that in them the concrete becomes abstract and the abstract becomes concrete, as the eye darts from brushstroke to photographic image in the same work. They are really dialogues between painting and photography.

Since first overpainting photographs in the late 1980s, Richter has increasingly engaged with this technique. The earliest examples listed in his catalogue raisonné date to 1986: large-format photographic prints overpainted using both a squeegee (leaving characteristic streaks of paint) and a brush. In 1987 and 1988 Richter overpainted just a few small-format photographs; in 1989, however, he started to extend and to work on this technique with a new intensity. Many of the early 'paint-overs' were made using motifs that Richter had photographed on his regular visits to Sils Maria, some of which were included in his Atlas. Leafing through the Atlas from that time, one soon encounters several plates with shots of the vast mountain-sides of the Alps against a blue sky. These are followed abruptly and surprisingly by the first paint-overs, in the same format: the shapes of the streaks of paint partly obscure the landscape yet also call to mind steep, craggy cliff-faces, so that already at this early stage there is palpable tension between the photographic motifs and the oil paint.

Richter told me that he often produced these overpainted photographs at the end of his working day. He would use the oil paint still clinging to the wide squeegee after he had finished

work on one of his large-format abstract paintings. The photographic prints are generally in the postcard format that is the norm for snapshots, and Richter usually has a box of these in his studio with a wide variety of motifs, which allows him to select at will an image that matches the leftover paint. He uses different techniques for overpainting: more often than not he pulls the photograph across the paint on the squeegee, so that the oil paint leaves streaks on it. Sometimes he places the photograph face-down on the paint and then lifts it off again, as though making a monotype. In certain cases, as in the pictures of Sils, Richter spattered the paint on the photograph, and in yet other cases more paint is applied later on with a small spatula.[3]

Some photographs only take up a little paint, others are almost entirely covered with paint. The images used for these paint-overs are not art photographs, but perfectly ordinary snapshots, the kind that anyone might take – portraits of family and friends, colleagues in the art world, captured on film by Richter at home, in his studio, on walks, on holiday or travelling; there are all kinds of landscapes, photographed at all times of year – forests and mountains, lakes and beaches – interiors and exteriors of buildings, everyday motifs.

Ever since the invention of photography in 1839 painters have engaged with this new image technology: Eugène Delacroix took instruction in the making of daguerreotypes, became a founding member of the Société héliographique in 1851, and variously used photographs of models as the basis for painted figures in the 1850s. Gustave Courbet also had photographs that he used as source materials and some of his paintings of waves, from the late 1860s, are evidence of his interest in the new pictorial medium, particularly the photographs of waves by Gustave Le Gray. Edouard Manet used photographs and press

reports of the shooting of the Mexican emperor for *The Execution of Maximilian* (1868–9). Photographs brought news of an event in South America to Paris. Lastly, there is even a photograph by Edgar Degas with traces of paint on it, which – however random they may be – nevertheless remind me of Richter's dabs of paint on photographs he used as sources early on.

In the twentieth century, with the ever increasing importance of image technology, countless, diverse connections arose between photography and painting. Photographs – as aids, as a source of inspiration and motifs – have taken their place in the painter's studio. The walls and floors in shots of studios belonging to a wide range of artists (such as Francis Bacon, to name but one) are often strewn with photographs and images cut out from magazines and papers, some with spatterings of paint on them. It seems that at some point, almost inevitably, the connection would be made between photography and abstract painting, not merely as a by-product of artistic activity but even leading to autonomous works of art. The fact that Richter came to identify the artistic potential and major importance of this connection is certainly partly due to the fact that, in the paintings he was making decades before he started overpainting photographs, he had already been actively exploring and reflecting on the levels of reality in photography and abstraction.

'We aren't capable of viewing paintings without searching for their inherent similarity with what we've experienced and what we know,' Richter once told me. His works are heterogeneous models which allow, even demand, perpetual change and mutation: 'Surprises always emerge,' he states, 'disappointing or pleasant ones.' His oeuvre is permeated by doubts and reservations about anything posited as absolute, whether a style of painting or an account of the world. He embraces contingency in artistic practice.

Our idea was not to take over the whole Nietzsche-Haus, but to work very discreetly in the interstices of the museum. Richter also created a small book as part of the exhibition. It had become clear to me that the book could not just be a subsidiary companion to the display, but a sort of exhibition of its own without a place. The book for *Sils*, as we called the exhibition, was the first of many textual collaborations between Richter and myself. In addition, in the room where Nietzsche wrote *Also Sprach Zarathustra*, Richter added a mirror-ball on the floor, which reflected the whole room. The ball focused the space and acted as a kind of formal evocation of the room's importance for Nietzsche. This reflecting silver ball was a gesture with a kind of solemnity but without sentimentality. As Richter has said about another work, it contained 'no saints, no message, and, in a certain sense, not even art'. Through Richter and Sils Maria, and Robert Walser as well, we can access alternate ways of conceiving art and the world. It is often an intuitive attraction to certain figures, certain places and world views that allows one to remain receptive to exactly these types of unusual curatorial opportunities.

Mentors

The museum is one truth, and this truth is surrounded by
many truths which are worth being exported.

– Marcel Broodthaers

There was a man standing against the north wall of the Romer-
brucke *Heizkraftwerk*, or power plant, barely visible. In 1990 I
had come to Saarbrücken, in the west of Germany at the border
with France, on an errand for my friends Fischli and Weiss. In
this case, the job was a droll one. The power plant was host to
a project inviting contemporary artists to create installations.
Fischli and Weiss's idea was to create a snowman, which they
would install in a glass refrigerator, powered by the excess from
the power station; as long as it generated electricity, there would
be a friendly, unmelting snowman on display. It was a typical
example of their work, expressing the plant's function – to cre-
ate the power to defy nature – in a charming way. And so I had
driven my creaking Volvo to Saarbrücken with a snowman in
the back – to be precise, it was a snowman dummy, a kind of
test mannequin for Fischli and Weiss's piece. I was to deliver it
to the curatorial staff.

The man waiting for me and the snowman, it turned out,
was the project's curator, Kasper König, a man whom Gerhard

Richter had always told me I should meet. In 1968, the year I was born, König was curating a celebrated exhibition of Andy Warhol's work at Stockholm's Moderna Museet. In the 1970s he had taught at the Nova Scotia College of Art and Design, and he returned to Germany and organized large-scale museum *tours de force* in the 1980s. One of these, the 1981 *Westkunst* exhibition in Cologne, created a transitional moment after which the art world became more global, more porous. As König said in a conversation, 'The title was a pun on the word *Weltkunst* (World art), and was meant as a conscious distortion of the kind of imperial ideology that we now consider old-fashioned.' Intimating the shape of the shift in artistic centres that would mark the late twentieth century, *Westkunst* was a monumental full stop at the end of an epochal sentence.

König is a cultural impresario. As an independent curator he carries museums inside his head and yet, as director of Cologne's Ludwig Museum, he was able to work within the constraints of an institution and open wide its potential. He uses the past as a toolbox to construct the future and has artists in residence at the museum to create a dialogue between the generations. He pioneered the concept of public art, erecting with his co-curator Klaus Bussman a series of installations and artworks all over the city of Munster every ten years in one of the most influential public art projects ever. His ideas helped me realize that art can appear where you least expect it and he taught me how to work with space – that art and architecture are intertwined.

When he was dean of the Städelschule in Frankfurt, an important art school that bridges the disciplines of art, design and architecture, König created a space next door called Portikus. It was little more than a container, but he made magic in it, inviting different artists to reinterpret the surroundings in

their own way. Most of his exhibitions arise from conversations with the artists, and a vital lesson he taught me was that it is not the job of a curator to impose their own signature but to be a mediator between artist and public.

We had met briefly before, and then at a dinner after an opening of the artist Katharina Fritsch. But in 1990, arriving with Fischli and Weiss's snowman dummy, I had a chance to speak to him at length for the first time. He ended up being one of my most important mentors. During our first conversation in Saarbrücken, we spoke a lot about books. König had edited a legendary catalogue for his Warhol show in Stockholm, and we discussed it at length. We also talked a lot about König's mentor, Pontus Hultén, with whom he had first worked at Stockholm's Moderna Museet and then at the Pompidou Centre in Paris.

Artists have been making books for centuries – witness William Blake's innovative self-illustrated books – but the artist's book has become an important aspect of contemporary art since the 1960s, when a number of artists began to use the book not as a complementary, explanatory sidekick to their 'real' work, but as a primary medium in and of itself. König recognized this potential early on and while teaching in Halifax he had edited the Press of the Novia Scotia School of Art and Design. There he published many books in conjunction with groundbreaking artists, from the choreographer Yvonne Rainer to film-maker Michael Snow to composer Steve Reich.

After our meeting in Saarbrücken, König asked me whether I would collaborate with him on an anthology, to be called *The Public View*. The idea was to create a sort of yearbook in which various artists and writers would be asked to create works that somehow dealt with the theme implied by the title. I began to

travel every week to work with him on the book in Frankfurt, where he was the head of the Städelschule. I started attending lectures at the school whenever I was in Frankfurt. Our book was really a kind of group exhibition and debate in the medium of print. During the process of making *The Public View*, König and I were struck by the difficult status of painting (debate in the art world continues to inspire proclamations of the death or resurrection of painting to this day), and so we began to conceptualize an exhibition of painters together. After we completed *The Public View*, my first book as co-editor, I visited Frankfurt with greater frequency, as we began work organizing an exhibition for the Vienna Festival that came to be called *Der zerbrochene Spiegel* (*The Broken Mirror*).

For the first time, I was curating a large show for a major institution – the exhibition space covered thousands of square metres, which raised the question of critical mass and how best to use such an enormous quantity of space. König and I wanted to undertake a survey of painting at a time when not many curators would exhibit paintings, and also to offer small retrospectives of work by some pioneering artists who had not yet received the exposure they deserved – like Maria Lassnig, Dick Bengtsson or Raoul de Keyser. In keeping with the historical survey method, our catalogue listed the artists in chronological order of their dates of birth. It was a key experience for me to work on such a big exhibition for the first time. As the Vietnamese General Giap said: 'If you win territory you lose concentration – if you win concentration you lose territory.'[4] When you have a big exhibition, I realized, you gain territory but the risk is that you lose concentration. Nevertheless, the critical mass in a large exhibition is very attractive. There are more works than you can perceive in a single visit, and there are many more zones of contact than in a normal exhibition.

But it was also a shock suddenly to have to work with – indeed to fill – thousands of square metres.

The Broken Mirror attempted to group together a wide array of painters without dictating a structure or thesis for how they should relate to one another. The exhibition was not to be a stage for an essay-like argument we were making about painting, but a discontinuous assemblage of possibilities. The mirror, of course, is the Western tradition's ultimate symbol for mimesis, or the representation of life. Painting was, by the late twentieth century, a broken mirror in the sense that its function had been superseded, its historical prominence among the fine arts challenged by other media. And yet it persisted within the 'post-medium' condition in an unstable, incoherent way. So we invited the widest range of painters we could, eventually ending up with three thousand paintings by forty-three painters.

One of them was particularly surprising: the Austrian painter Maria Lassnig (born 1919), with whom I began a long series of conversations. Displayed in The Broken Mirror among many much younger artists, Lassnig's work seemed to have a remarkably radiant power. Her paintings became a kind of show-within-a-show.

As we prepared The Broken Mirror, I was also travelling regularly to Paris to work with my another of my most important curating mentors, Suzanne Pagé. Pagé was the director of the Musée d'Art Moderne de la Ville de Paris, and Christian Boltanski had introduced me to her and her curator, Béatrice Parent. If König had taught me about making books and large-scale exhibitions, from Pagé I learned how to run a museum. She ran the Musée d'Art Moderne as a laboratory, but one that performed this function hand in hand with its role as a guardian of memory. She organized historical exhibitions featuring artists

of the modern period – for example, Giacometti, Bonnard or Picabia – but always with a contemporary twist.

Pagé had curated many important solo shows in Paris, from Louise Bourgeois to Hanne Darboven to Sigmar Polke to Thomas Schütte to Absalon. She had also made innovative group shows that were organized thematically, such as her exhibition on the 1930s in Europe, *Années 30 en Europe*. She had begun as the director of L'ARC, the Animation, Research and Confrontation institute, and Pagé was now charged with the responsibility of opening the Musée d'Art Moderne de la Ville de Paris to a greater range of contemporary art. Her mission was to encourage a wider audience to visit the museum, as a response to the sociological critique of figures like Pierre Bourdieu, who had argued that 'high' art, along with other forms of taste, functioned as a signalling system for the cultural elite. So Pagé pioneered exhibitions of outsider art to counter this tendency, and worked to bring visual art closer to music, cinema and poetry.

Above all, the Musée d'Art Moderne under Pagé was a museum of, by and for artists. She always involved contemporary practitioners, even in historical exhibitions, believing that the eye of an artist would always reveal unnoticed correlations and correspondences. She would also ask artists to look into aspects of the museum's collections that appealed to them and to make projects based on their discoveries, as in her legendary exhibition *Histoire de Musée*. Thus she maximized both the archiving and creatively generating functions of her institution. Pagé came from a classical background, having studied Latin and Greek and then seventeenth-century painting at the Sorbonne. This had led her not to pit the past and the present against each other but instead to encourage their intermingling

through her inspired curating. A product of the May 1968 civil unrest in Paris, she wanted to produce a new inclusivity and invite new audiences to engage with the museum.

Pagé, having run a large institution for many years, seemed interested by the lightness of the smaller exhibitions I had been doing: the kitchen, the monastery library, the Nietszche-Haus and the Hotel Krone restaurant. She asked me to do a project for the interstitial areas of the Musée d'Art Moderne. I was very excited by the lightness of the idea of a micro-lab of radical experiments within a big institution, thinking of Robert Musil's idea of the future of art, which, he said, would happen where you expect it least. Out of this request from Pagé, I developed a series of exhibitions called *Migrateurs*. Several times a year, we would invite an artist to develop a project. In the first phase they would decide where and in what form to intervene, in an intense discussion with the museum; however, the site of intervention was never predetermined. *Migrateurs* was an attempt to create a mobile platform within a large institution. Without the usual pressure to occupy thousands of square metres, it was a kind of public laboratory in which ideas could be tested.

Gertrude Stein, who collected and displayed in her Paris atelier works by Cézanne, Picasso, Matisse and many others, once questioned whether museums, which she called 'cemeteries' of culture, could ever be modern. For Suzanne Pagé, the answer was yes: for her the museum could perform a double function too, as a repository of time past and as a laboratory for future practice.

During the *Migrateurs* exhibitions I realized that, by collaborating with the artists, I had found a way to formalize something that had emerged in my work as a young curator: the oscillation between large art institutions and exhibitions in unusual places in the context of everyday life. Institutions are not the only places

where official history of the field is written, but they attract by far the largest audiences – they are the articulation points where one can reach the mass audience. Also, their permanent collections offer an archive that can be kept alive by being reactivated and recombined with contemporary practices. The everyday-life exhibitions, meanwhile, offer a different chance to experiment. A dialectic had become apparent in my practice between large and small spaces. My experience curating *The Broken Mirror* prompted a return to micro-spaces, in the style of my first exhibition in the kitchen. In *Migrateurs* I could play with large and small, institution and infiltration, museum and laboratory.

One of the first artists I invited for the series was Douglas Gordon. He was soon to become internationally prominent due to his experiments with cinema and time – for instance, in his most well-known work, projecting Hitchcock's film *Psycho* at a speed that rendered it a twenty-four-hour experience.[5] At the Musée d'Art Moderne, Gordon installed a text piece, 'From the moment you read these words, until you meet someone with blue / brown / green eyes', as both a wall drawing and as a message one heard when using the museum's telephones. When encountered, either by a visitor reading the wall drawing or by anyone making a call, the text piece occupied the perceptual space of the visitor, 'highlighting' the time between receiving the message and meeting a person with the appropriate eye colour as an artwork. The artist was migrating his work outside the official gallery space of the museum, outside Cartesian, physical space altogether. Musil, I believe, would have appreciated it: this was art where you least expect it.

Soon after, as part of the *Migrateurs* series, the artist Rirkrit Tiravanija took as his area of interest the line between observation and participation. Tiravanija installed a kitchenette, in which anyone could make themselves tea or coffee, in the

stairwell between the historic collections and the contemporary galleries. People became used to its presence, though without necessarily realizing that it was an artwork, leading to an interesting phenomenon: only at the moment of the work's removal did it become noticed. Many of the *Migrateurs* projects similarly verged on invisibility.

Felix Gonzalez-Torres, who influenced many artists of my generation, changed the relationship between galleries and museums and their visitors. When I invited him to participate in *Migrateurs*, he decided not to install work in the visited portion of the museum at all. Instead, he was inspired by the contextual interventions of earlier artists like Michael Asher, whose works often responded to the history of the particular context for which they were produced. Gonzalez-Torres, in turn, was interested in infiltrating all the social spaces of the museum. He hung a billboard at the museum's entrance, which he had also done at the Museum of Modern Art in New York. He also bought vases and flowers from nearby markets and placed bouquets in the museum's offices. Visitors would not see this work, since they did not normally have access to the office areas. Only the staff experienced this change to the museum environment.[6]

While I was working for Pagé and König, I met the late Josef Ortner and Kathrin Messner, who in Vienna had founded the *museum in progress*, which was a mobile platform for exhibitions in print, on television, billboards or the Internet. They would have artists become involved in their chosen art form and create an exhibition within mass media. They had established a cooperation with the Ministry for Education and Culture and also with the daily Austrian newspaper *Der Standard*, which provided space in its publication for artists on a regular basis.

I had read about the *museum in progress* and found it fascinating, an initiative that channelled many of Alexander Dorner's ideas. It also echoed my own desire to create exhibitions in unexpected places. Ortner and Messner, however, were using the more popular sites of 'new media': subways, the airwaves, magazines – networks of urban and global circulation.

We discussed their ideas further and in 1993 I agreed to begin curating a series of projects for the *museum in progress*. For one of our first projects I fulfilled a long-held desire by helping Alighiero Boetti produce his piece for Austrian Airlines. Together with Kasper König, we also invited Ed Ruscha to create two enormous pictures, which were printed in large panels with the help of computer-aided design. These pictures, which were ten by fifty metres, adorned the outside of the Vienna Kunsthalle during *The Broken Mirror* show. The work questioned the easy assignment of authenticity to painted works and artificiality to mechanically reproduced works, which was a theme of the *museum of progress*. It was appropriate that the pictures were by Ruscha, one of the first important conceptual artists in America, who had started in graphic design and had been a billboard painter in California.

Félix Fénéon and the Hotel Carlton Palace

During my work in Paris, I discovered Joan Halperin's fascinating biography of the French critic, editor, collector and anarchist Félix Fénéon, who became another inspiration to me. Fénéon began his professional career as a clerk. Born in 1861 in Turin, he was raised in Burgundy during a period of political turmoil and cynicism, and developed anarchist-communist views from a young age – at age twelve he started the *Societé de la mort facile* (the 'Society for Those Willing to Die'). As a student, he won a competitive exam that got him a job in Paris's War Office. He worked there for thirteen years, eventually becoming head clerk. In his spare time, Fénéon created an influential 'little magazine' called *La Libre Revue* (*The Free Review*). He served as its editor and critic, and he also published the work of the Symbolist poets and pioneers of experimental poetry, Verlaine, Rimbaud and Mallarmé. For Fénéon, literature and visual art were inseparably interwoven, and he is credited with developing a new, modern style of interpreting paintings that 'read' them as texts.

Fénéon was a bridge between and a crucial ally of avant-garde poets and artists. This depended in small part on his dandyish personal charisma – according to Mallarmé, 'there was no one who didn't enjoy meeting him'. While writing on art and becoming an integral part of the Symbolist movement, Fénéon

came into close contact with the painter Georges Seurat. He later noted, 'The art of Seurat was revealed to me by "A Swim (Asnières)". Though no trace of my reaction remains, I realized completely the importance of this tableau: the body of work that was its logical consequence followed without my joy being colored by the pigment of surprise.' Thereafter, Fénéon worked to bring Seurat to the attention of a wider public.

A figure with many secretive qualities, Fénéon pursued most of his endeavours behind the scenes, perhaps most notoriously his anarchist political activities. In 1894 he was widely suspected of bombing the restaurant Foyot in Paris, a destination for senators and the wealthy. The bombing killed no one, and he was acquitted in the ensuing trial, but much anecdotal evidence points to him, including the detonator caps that police found at his office. But Fénéon was enigmatic even beyond politics. The founder of a dozen small magazines, editor of the *Revue Blanche* and the *Revue Indépendent*, the first French publisher of James Joyce, and translator of Jane Austen, he never produced an autobiography. Neither did he write about himself in his essays, which he often signed with pseudonyms, preferring to remain in the shadows. A typical writing project was the set of three-line news items, *Les Brèves*, which he wrote anonymously in 1906 for the Paris newspaper *Le Matin*.[7]

After 1910, Fénéon sold paintings for the Bernheim-Jeune gallery, promoting the work of many of the same artists he had earlier championed in his criticism. The son of a travelling salesman, his journey through life was peripatetic, reflecting his many identities and professions. Fénéon was also indifferent to personal prestige, rarely if ever playing a public role, despite curating several important exhibitions. That indifference, and his non-linear, discontinuous biography, meant that the influence he exerted over *fin de siècle* artistic culture, though attested

to by many, is difficult to trace. We owe much to the historian Halperin, who recovered the fragments for her biography. In his various initiatives Fénéon, to those around him, always seemed to function as a catalyst, a chemical term he used to describe the task of the curator. In history, as in chemistry, the catalyst disappears.

One passage in Halperin's book on Fénéon directly influenced my work. It described a small painting sent to him by Seurat, *Modèle debout, de face*. Fénéon said that it 'would glorify the noblest museums', and the picture became his most treasured possession. He made a small velvet case for it and for two other canvases from the same series, *Modèle assis* and *Modèle assis, dos*. He bought them sometime after Seurat's death in 1891, and took them with him each time he left Paris – in the inside pocket of his waistcoat. Their 'style, of a dignity and serenity and of an indescribable distinction, filled the most pedestrian hotel room with life'. The image of Fénéon's mobile, private exhibition of Seurat in a hotel room became the inspiration for one of my earliest exhibitions in Paris, held in a room at the Hotel Carlton Palace.

This show followed an evolutionary principle: in contrast to a static exhibition, which does not change after the opening, new works were constantly added and occasionally the artists exchanged the items they had first exhibited for other ones. In the beginning, my hotel room was empty, but little by little works began to accumulate. At first I had to sleep with Annette Messager's stuffed animals. Gloria Friedman, Bertrand Lavier and Raymond Hains all stayed there, among a few permanent residents, some of whom had lived in the hotel for thirty years.

There was also a group show in the wardrobe: the visitor was invited to try on the clothes. Dominique Gonzalez-Foerster transformed the bathroom into a yellow room. I also discovered

that On Kawara had stayed in the hotel in the mid-1960s, and he had made drawings there, which I was able to borrow and display in the show. Hans-Peter Feldmann contributed a suitcase filled with his personal archive of photographs, and Christian Boltanski sent a photo album. A claustrophobic and soundless videotape by the Israeli sculptor Absalon ran continuously on the TV. Fischli and Weiss sent a cassette for me to play on a loop containing a recording from the radio, which would confuse September visitors with its out-of-date weather reports of a heatwave in July.

Andreas Slominski sent instructions by fax for me to carry out every day, as a sort of punishment for the curator. Some of the instructions were very open-ended, which allowed for, or even encouraged, great interpretive freedom. On the first day, the instruction read simply 'Kikeriki', which is German for 'cock-a-doodle-doo'. On the second day it was 'Lie (change artists' names)', which I interpreted by swapping the artists' labels in the exhibition. On day seven, I had to put the cork from a bottle of German *sekt* sparkling wine in the pocket of my Sunday trousers: 'Sektkorken in Sonntagshosentaschen'. Day eight was particularly difficult: I had to clean the person who was cleaning the room. (Slominski had worked at a home for the elderly during his military service, where part of his duties included bathing them.) On day twelve, I had to throw a bucket of water out of the window every hour.

On day twenty, I had to let all the air out of a football in order to refresh the room and then throw it out of the window. The next day, I had to retrieve the ball. On day twenty-two, the instructions read 'leaf guests for a leaf hotel', which referred to a project Slominski had been working on that called for transposing the leaves at the bottom of a tree to another tree, which no one would suspect. The next day, continuing the obscurity,

the instructions simply read, 'an incomprehensible idea'. Day
thirty called for a freshly painted wall, which was very compli-
cated since I had to paint it in the morning and some visitors
got paint on their clothes. One woman even threatened to sue
me for damaging her coat; this was a trap set by Slominski.
Since the show changed daily, people would return again and
again, and some even came to see what he had asked me to do.
The actions were never formally announced, but I would explain
to people who asked that they were seeing an Andreas Slomin-
ski piece. Some even expressed concern over how I was executing
the instructions – in a way, Slominski's work turns the tables by
keeping the curator occupied in the installation at all times.
From 22 August until 22 September, 10 a.m. to 6 p.m., I was the
landlord, curator, exhibition guardian and guide. As Harald
Szeemann told me on a walk in Appenzell: 'The curator has to
be flexible. Sometimes he is the servant, sometimes the assistant,
sometimes he gives artists ideas of how to present their work;
in group shows he's the coordinator, in thematic shows, the
inventor.'[8]

Invisible Cities

One rainy Wednesday after finishing the Hotel Carlton Palace show, I got a phone call from Peter Fischli and David Weiss. This time it didn't have to do with transporting a snowman dummy, but with an idea they had for me to follow up my shows in the kitchen and the hotel. They said, 'There is a place you should know', and in my ongoing exploration of the boundaries between museums and everyday life, an irresistible project presented itself. It turned out to be the *Stadtentwasserung*, Zurich's sewage museum. They had discovered it while they were shooting a film in the sewers of Zurich and had to collaborate with the city's sewage administration.

The sewage museum recounts the history of toilets from the Middle Ages to the present – they mount toilets on pedestals without reference to Duchamp's urinal. Intrigued by the space – what could be more relevant to the history of our cultural distinctions between public and private? – I approached the municipal government of Zurich about mounting an exhibition there. The municipality knew neither the artists nor me, so I explained the project from the beginning, and related it to my other exhibitions in unusual spaces – an interesting experience in its own right. Luckily, they agreed to collaborate with us and we opened the show in early 1994.

Cloaca Maxima, as the resulting exhibition was called,

addressed themes that affect everyone directly. There were many connections to the permanent collection of the *Stadtentwässerung* itself, though the point of departure was the video by Fischli and Weiss, which consisted of real-time photographs from observation cameras in the sewers. According to Dominique Laporte's *A History of Shit* (1978), waste in Western societies has been gradually domesticated and, hence, banned from public view, the high point being the nineteenth-century hygienist movement. Laporte theorizes that the absolute division between the economy (as the site of filth) and the state (as the site of purity, with an all-filtering sewer) separated the private still further from the public, thereby reinforcing their borders.

Art, by contrast, situates itself within transitions and passages; it opens up opportunities for the public incursions into the private and vice versa. Excrement is freed of its negative connotations by being employed discursively. Piero Manzoni's *Merda d'artista* (small sealed cans, each said to contain 30 grams of the artist's shit) plays with exactly this kind of alchemical transformation – reinforced by the fact that the price per can was comparable to the price for 30 grams of gold.

John Miller produced scatological images and reliefs; Nancy Spero's drawings of bombs dropping depicted warplanes and helicopters as man-eating beasts, defecating on the world. Otto Muhl proposed a defecation altar that ironically combined Duchamp's urinal and Manzoni's cans. Gerhard Richter sent a photograph of his painting of a toilet paper roll.

The *Stadtentwässerung* is a small, quiet museum. Normally, only ten to twenty people a month visit, but with our exhibition it suddenly gained public attention. This led to a mixture of different audiences: visitors to the sewage museum saw contemporary art while the rather large art audience discovered

this 'surreal' location. For the opening, the employees of the sewage institution with their uniforms and a sewage van fetched the artists from the airport, drove them from the airport to the museum and also to the dinner after the opening. These were moments of creative intermingling, not just of art and life, but of art in a museum with a very different – and yet deeply related – function.

London Calling

Ringing the bell at Gilbert and George's house at number 12, Fournier Street in East London, is always a magical experience. On my first visit to their house, as a teenager, they likened the evolution of their career to a pilgrimage, telling me that John Bunyan's *Pilgrim's Progress* was the model of their *joie de vivre* – of their desire continually, and uncompromisingly, to discover life anew. Because the penultimate destination of their pilgrimage remains unknown, it is predicated upon but one binding rule: the persistent dreaming of what Gilbert called 'something better or more interesting. The dreaming world is something extraordinary in art. Ultimately, it's why artists are always able to do something more. I really believe this.' The idea of art as a pilgrimage, and of making pilgrimages to art, has stayed with me ever since.

Gilbert and George's work *Waking* (1984) is composed of a grid of 132 panels, it is among the duo's earliest large-scale wall-mounted pieces that have today become emblematic of their oeuvre. *Waking* is derived from black and white photographs of the artists and some of the male models they have been photographing near their studio on London's Fournier Street for decades. (The same model seldom appears twice in their work.) Repeated images of the artists, each appearing

three times at different scales, occupy the centre of the grid and are flanked on either side by images of the models in various poses. In the background are eleven disembodied heads, enlarged to an imposing scale and bearing a range of expressions.

Waking still seems amazingly fresh – timeless, even. I asked the artists about this, and they suggested that it is due to the methodology they apply to picking their models:

> Gilbert: It's funny that you mention the models, because *Harpers and Queen* came to photograph us and wanted to know why all the models in our pictures look so up-to-date. They don't look dressed up in an old-fashioned way; they look completely like they could be now, very trendy.
>
> George: We never wanted to use a model who had a social sense . . . where you would say, 'Oh yes, this is a bank manager's son,' or, 'This is a serious student.' We always wanted to use our models like we use flowers: flowers for beauty, and people for humanity (in the broadest sense). It's a delicate, strange thing, that.
>
> Gilbert: I think we would call them 'classless'.

Characteristically, the images within *Waking* have been abstracted from their likeness by the application of a wash of red, blue, white, green and yellow that suggests a Mondrian-inspired heritage. But unlike, say, De Stijl's pursuit of utopian geometries, or Piet Mondrian's particular preoccupation with emptying theosophical spirituality into form, Gilbert and George appropriated the loaded symbolism of stained-glass windows to make a picture that is at once ironic, ambiguous and powerful.

As they told me in relation to the piece:

We always think that waking is one of the most important moments of a person's life. It is the beginning of a new day. You know, Welsh people call the early morning 'morning wood', because every male wakes up with a hard-on. And all sex advisers always say if you have a problem with erection, then do it in the morning. It's a moment of purity, the time when everyone has their first idea of the day. When a young artist asks, 'What would you advise us?' we always say, 'When you wake up in the morning, sit on the edge of the bed, don't open your eyes, sit on the edge of the bed and think, "What do I want to say to the world today?"' Because they are normally students, I suppose we also tell them, 'Fuck the teachers.' But, really, it doesn't matter whether you have a computer, a brush or a pencil, just decide what you want to do and you'll be fine. Waking in the morning is like staring into the abyss, looking into the universe.

On my first trip to their house Gilbert and George taught me about the beautiful plaques that mark the homes of Londoners of the past. Later in my trip, I found one of the blue plaques at 33 Thurloe Square, near the Victoria and Albert Museum, marking the house of the museum's creator, Henry Cole. By chance, I had seen it on my first trip to the city. It turns out he was a fascinating character and a true pioneer of exhibition-makers. Cole created not only the V&A but many of the landmark cultural institutions that populate South Kensington.

A founder of museums, he was also the head of a department of the civil service, a designer of ceramics, a social reformer, the creator of a system of art schools, and the driving force behind a number of international exhibitions, most famously

the *Great Exhibition* of 1851 in London, which was held in the newly erected Crystal Palace in Hyde Park. Cole was a giant amongst nineteenth-century British administrators, and one of the first to demonstrate what could be accomplished at the level of institution-making. Like other great achievers of his century, his accomplishments are dazzling in their variety.

Born in 1808, Cole was educated at Christ's Hospital, one of the best private schools in Sussex, and the only one that offered poor boys such as him scholarships. He described the meagre meals and harsh punishments he received there in the notes to his autobiography, recounting episodes such as being beaten severely for refusing to return to a lesson in which he had already demonstrated proficiency by reciting Ovid's *Metamorphoses*. These early disobediences only marked out more clearly the strength of will that was to define his professional life for many years to come. Cole did not feel he learned much of use at Christ's Hospital, but the excellent penmanship he developed there got him his first job as a copying clerk. From an early age he had been part of a circle centred on John Stuart Mill, the great Utilitarian philosopher and advocate of rationalism in government. Cole worked in the public record service for years, transcribing parliamentary records and writing reports. At the same time, he wrote essays and articles in favour of social reform, and reviews of art, music and drama in newspapers.

In the 1840s, when railways were shrinking the distances between cities, Cole also wrote for and edited the *Railway Chronicle*, one of the first periodicals to explore this radical change in the experience of space and time. Writing soon led him into the arts. Cole drew and played music from a young age, and as soon as he was able, he visited art galleries. He began to write art criticism and then guidebooks to architecturally and

artistically significant sights, such as Hampton Court Palace, under the pen-name 'Felix Summerly' (public servants were barred from publishing under their own names). Cole followed these with a series of children's books under the same name.[9]

In nineteenth-century Britain, much of what we recognize as the modern world was coming into being. For the first time, industrially produced objects were available, and bodies like the Society of Arts were formed to promote the new possibilities for art and design. Cole became deeply involved in shaping these opportunities from many angles at once. He was an exhibition-maker, a writer, a designer, a bureaucrat and an advocate of design and patent law reform, and he started a monthly magazine in which to address all of these issues, the *Journal of Design and Manufactures*. He became the driving force in the Society and organized large exhibitions of new manufacturing processes. It was an era of rapid advances in design, technology and copyright practices, and exhibitions were the primary vehicle for information about these developments to circulate. All of Cole's activities and interests coalesced in exhibition-making, and the work that made him a famous Victorian figure was organizing the *Great Exhibition* of 1851.

As the full title, the *Great Exhibition of the Works of Industry of All Nations*, indicates, Cole's ambitions were global. With his patron, Prince Albert, he had conceived of the exhibition as the first great international festival. Cole aspired to bring to Hyde Park nothing less than examples of the highest developments in manufacturing from around the world: spices, foods, minerals, machinery, engines, looms, bronze sculpture and plastic art. As he said in a speech announcing the event: 'In short, London will act the part of host to all the world of an intellectual festival of peaceful industry, suggested by the Consort of our beloved Queen and seconded by yourselves – a festival, such as the world

has never seen before.' Half the space that visitors came to see was devoted to British works. In the other half, Cole allocated space to various countries in proportion to their amount of trade with Britain – so the exhibition produced a picture of the world that was also a picture of Britain's relationships with the world.

Cole's vision was a modern and democratic one, welcoming all classes of people. He incorporated music, opening and closing the exhibition with a recital of Handel's 'Hallelujah Chorus'. Cole, always an optimistic reformer, believed the exhibition would foster greater cooperation between nations – these were the early glimmerings of a cosmopolitan understanding of the world. Reflecting another modern element, the exhibition budget came not only from a government subsidy but had to be raised privately, and Cole spent two years fund-raising. The building that was erected at great speed to house the exhibition was also a spectacular example of modern technology: an iron and glass design by James Paxton, 1,848 feet long and covering 19 acres, that came to be known as the Crystal Palace. The railways were persuaded to offer discounted fares to visitors, allowing thousands to visit the exhibition and giving an early boost to railway ridership. The Crystal Palace became an icon for the age of Victorian optimism, and a testament to the power of a new cultural format: the large-scale public exhibition.

From their roots in the medieval processions of the guilds to today's Biennales, roving exhibitions in temporary spaces have always played a significant part in the history of the format. In the nineteenth century, with the coming of industrialization and increasing global trade, exhibitions became a way to gather and display the multiplicity of produced objects and the developing techniques for manufacturing them.

Cole's career flourished at a time when modern democratic institutions and technological advances made exhibitions a

crucial form of exchange and display. He went on to develop the entire South Kensington area as a district of museums, schools and societies, and became the first director of the South Kensington Museum, now the Victoria and Albert Museum. In all of these endeavours he displayed prodigious quantities of energy and dynamism. In none of them did he work alone: his genius was for navigating amongst allies and opponents to achieve his goals within large collaborations. Cole played his unheralded role, that of the civil servant administrator, so skilfully and effectively that by the end of his life he was something of a national treasure, known as 'Old King Cole', after the children's nursery rhyme.

Architecture, Urbanism and Exhibitions

From Hentry Cole I learned that curating can be urbanism, that it can be about the mutations of changing cities. This came together further when I was working with Kasper König in Frankfurt, where I began attending lectures at the Städelschule, an art school with a small, embedded architecture department. These lectures whetted my appetite for the subject, which had cross-pollinated with art throughout the twentieth century. But I received an even bigger boost on a trip to New York, where I met the artist Dan Graham, who has a truly encyclopedic knowledge of architecture and whose pavilions are a form of art and architecture mixed. Graham gave me a blizzard of suggestions for books by architects I had to read, starting from Robert Venturi and Denise Scott Brown's *Learning from Las Vegas* (1972). Graham also told me about mid-century Japanese architects who were completely new to me, and the connection to Asia was one I followed up on in the years to come.

My first project that involved architecture and urbanism came about through a collaboration with the curator Hou Hanru. We curated an exhibition about art, urbanism and the Asian mega-city, which we ended up calling *Cities on the Move*. Hou and I had spoken very early on about *Magiciens de la Terre*, the groundbreaking 1989 exhibition curated by Jean-Hubert Martin – we had discussed what it meant that Western curators curate such shows

and how interesting it would be if there was a meaningful back-and-forth between a Western and an Eastern curator. That's when Hou Hanru and I decided to do an Asian show together.

We felt there was an explosion of creativity and new forms in Asian cities in the 1990s. Rather than formulate a theory about this from afar, we began to visit various cities and ask questions, letting artists and architects guide us to what they considered to be urgent. This was a similar process to that behind Harald Szeemann's influential 1969 show *When Attitudes Become Form*, which came about when Szeemann visited Jan Dibbets in New York, who told him about emerging artists all over Europe and the USA, which in turn led him . . . exhibition-making is an organic process.[10]

In the early summer of 1995, while researching *Cities on the Move*, Hou Hanru and I attempted to pay a visit to Rem Koolhaas in Rotterdam. He was too busy to see us there, and was bound for Hong Kong the next day to continue his research on the Pearl River Delta. 'Guys, we should talk about Asia in Asia, not in Rotterdam. See you tomorrow in Hong Kong!' was his parting message for us. Hou and I took this message quite literally, and bought plane tickets to Hong Kong immediately.

The next evening we had dinner with Rem. That was really the key moment when *Cities on the Move* was born, because we discussed how it would be much more interesting to do an exhibition on cities rather than just on Asian art. Very often nations are imaginary constructs, as Benedict Anderson has said. Regions and continents are even more so, and it's very important to acknowledge that we're living in a transnational moment. It seemed important to go beyond national boundaries and focus instead on cities – because the driving force of the 1990s was really these urban mutations.

The initial encounter with Rem Koolhaas in the run-up to *Cities on the Move* also stimulated my own professional involvement with urbanism in Asia, as well as my interest in the idea of the *city as process*, stemming from Rem's own engagement with the rapid mutation of the urban fabric in the sprawling mega-city region around Hong Kong. Koolhaas encouraged us to track down and interview a number of architects in various important cities. We took his advice and travelled to Kuala Lumpur, Seoul and Djakarta, as well as to Singapore, where we met and interviewed the architect Tay Kheng Soon, whose research on the sustainability of mega-cities led to his vision of bamboo cities.

Koolhaas communicated his own abiding interest in the Asian avant-garde architectural movement known as Metabolism. Accordingly, we travelled to Tokyo, where we met some of the protagonists of Metabolism for the first time: Maki, Kurokawa and Kikutake, as well as Isozaki. Eventually, Koolhaas and I would attempt to create a book based on an oral history of the movement, and together we recorded conversations with Kawazoe, Otaka, Asada and Awazu, along with other architects and thinkers linked to, and descending from, the Metabolists. The conversation with Koolhaas has continued ever since.

While I was researching *Cities on the Move*, the artists Rita Donagh and Richard Hamilton, with whom I often discussed architecture and exhibitions, said it would not be possible to do a show about the mutations of cities without talking first with Cedric Price. They rang him, saying we were all very keen to hear what he had to say, and we met very soon after – that was the beginning of many years of ongoing conversations, sometimes weekly, sometimes twice a month. It demonstrated that simply introducing two people who one thinks should know

each other can have a major effect on future artistic practice, whether through the impact they can have on each other's work or through entirely new collaborations. It's another form of curatorial practice, and I have continued it ever since.

Price participated in *Cities on the Move*, and we talked often about the concept of the exhibition as a learning system with a potentially complex and dynamic series of feedback loops that can be brought into other contexts, and that eventually can have an impact in political circles. Cedric developed most of these ideas in the 1960s, at a time when cybernetic thinking was very much on people's minds. This particular intellectual influence can be discerned in many of his projects and statements, for instance the idea that algorithms and computer programmes would facilitate architectural design – something we take for granted nowadays.

From the time he opened his own practice in London in 1960, Cedric Price has been one of architecture's most influential figures. Although very few of his structures were actually built, his visionary ideas and proposals for urban development have made a huge impact, and his influence on architecture today is immeasurable. Nowadays I often give lectures in architecture schools, and I find it extraordinary how his influence has actually grown even more over the last couple of years. Many architects have attested that Price was their greatest influence. And not only in Europe: he is also an immense influence on architects in Asia. One of the major themes, other than time and movement, that is central to Cedric's thinking and his whole work is his opposition to permanence and his discussion of change. His ideas continually push against the physical limits of architectural space and the trajectories of time.

Price's conviction that buildings should be flexible enough to

allow their use to serve the needs of the moment reflects his belief that time – alongside breadth, depth and height – is the fourth dimension. He was resolutely opposed to a top-down vision of architecture's place in society, as a way of prescribing people's way of living and of dictating change. In a very revealing statement, Cedric once said to me: 'At the beginning of the twenty-first century, dialogue might be the only excuse for architecture. What do we have architecture for? It's a way of imposing order or establishing a belief and that is the cause of religion to some extent. Architecture doesn't need those rules anymore, it doesn't need mental imperialism, it's too slow, it's too heavy and anyhow I as an architect don't want to be involved in creating law and order through fear and misery.'

Cybernetic thinking played a crucial role in the development of Price's own architectural thinking, especially with respect to ideas such as transience, evolution, change, chance – what the computer theorist Peter Lunenfeld calls 'the unfinished', that is, incompleteness. At a group show I curated with Margaret Richardson at Sir John Soane's Museum, Price developed badges for all the guards. He asked me to interview all of them and write down their stories. I brought him the stories and he then made drawings of them, which were worn by the guards as badges.

We also collaborated on a portable museum, called the Nano Museum, in the mid-1990s. Hans-Peter Feldmann (in this case a sort of readymade architect) had found a two-part picture frame, about two by three inches, which became the museum's structure. Cedric then created the museum's first show by folding a paper cup into the confines of the frame. This frame then became a minuscule museum on the move, not unlike Fénéon's mobile Seurat show, which I carried around with me wherever I went for several months, showing Cedric's exhibition to almost

everyone I encountered. At two by three inches it was perhaps the ultimate example of spatial extremes in my curating trajectory. It also came to symbolize the idea that museums might one day disappear from our lives: the next artist to exhibit in my Nano Museum was Douglas Gordon, who after receiving the empty picture frame in which he was supposed to develop his show, tragically lost it in a bar in Glasgow.

Biennials

Biennials have become a global phenomenon. Over the last two decades the Venice Biennale (first held in 1895), New York's Whitney Biennial (begun in 1932) and the São Paolo Biennial (founded in 1951) have been joined more recently by important biennials on all continents. The second half of the twentieth century witnessed a multiplicity of art centres on all continents. Since the 1990s, biennials have contributed considerably to this new cartography of art.

Critic and curator Lawrence Alloway described the Venice Biennale of 1968 as 'an orgy of contact and communication'; this gives a good sense of how important these events had already become to the formation of collaborative ties that lead to new artistic projects. Alloway also pointed out that the Venice Biennale was a kind of goal for all exhibitions to aspire to, which has allowed the exhibition to be seen as a stand-alone structure – itself something of an artwork.

We are living through a period in which the centre of gravity is transferring to new worlds. Opposing what he called the 'irreversible' aspects of globalization (uniformity, homogeneity), the philosopher Étienne Balibar once explained to me the need for artists and exhibitions to become nomadic, physically and mentally travelling across borders. He described how going beyond national boundaries would allow languages and cultures

to spill out in all directions, to broaden the horizon of translating capacities. In this way, Balibar said, 'Exhibitions would be borderlines themselves.'

An example of this principle occurred in 2002 at *Documenta*, the exhibition in Kassel, Germany, that is held every five years. The 2002 edition was curated by Carlos Basualdo, Ute Meta Bauer, Susanne Ghez, Sarat Maharaj and Mark Nash, under the artistic direction of critic, poet and curator Okwui Enwezor. Instead of trying to make a standard exhibition on one site, they created a series of five symposia, called 'platforms', around the world. The exhibition itself was conceived as the fifth of these platforms, rather than the primary event, stressing that contemporary art should be understood through an 'off-centre principle'. Rather than standing at the centre of these creative platforms, the viewer of Enwezor's *Documenta* was made aware there were other activities going on elsewhere, and therefore a comprehensive view was not possible. Enwezor's goal, as he put it, was to achieve 'provincial modernity' – in the spirit of Édouard Glissant's idea of a 'poetics of location'.

The temporary exhibition can also serve as a reciprocal contact zone mediating between museum and city and inventing new exhibition formats. The current multiplication of biennials means that rather than copying the formats of other ones, the challenge is to provide new spaces and new temporalities. It is urgent to generate a situation that is receptive to interesting, more complex spaces, combining the large and the small, the old and the new, acceleration and deceleration, noise and silence. Biennials today need to provide new spaces and new temporalities in order to achieve Glissant's *mondialité*: a difference that enhances the global dialogue.

One great potential of the biennial, or the triennial, is to be a catalyst for different types of creative input in the city: biennials

are a form of urbanism. The multiplication of these events is reflected by the multiplication of artistic centres. The competitive quest by museum directors and curators during the twentieth century for the one iconic art centre has been overtaken in the twenty-first century by the emergence of a multiplicity of possible centres, and biennials are making an important contribution to this. They can also form a bridge between the local and the global. By definition, a bridge has two ends, and as the artist Huang Yong Ping points out: 'Normally we think a person should have only one standpoint, but when you become a bridge you have to have two.' This bridge is always dangerous, but for Yong Ping the notion of the bridge creates the possibility of opening up something new. By resorting to the notion of chance, one can gain access to enlightenment.

Often the biennial is a trigger for a dynamic energy field that radiates throughout a city. This works particularly well when all the exhibition spaces and institutions in a city participate in a joint effort to form a critical mass. Biennials and other large-scale exhibitions can also trigger many self-organized side events in a city. One great potential for a biennial is that very often it becomes a spark or catalyst for something else in the local scene.

Biennials are a continuously articulated struggle between the past, the present and the future. This is a vision of history under constant negotiation. Assessing past biennials is hardly a novel idea. What, then, of the future of the biennial? We should emphasize that visions of the future both evolve over time and proliferate. The future of the biennial, in other words, is both varied and plural.

Utopia Station

Biennials are both places and non-places. This contradiction animated a project I executed as part of Francesco Bonami's Venice Biennale of 2003, working with the art historian Molly Nesbit and the artist Rirkrit Tiravanija. We called it *Utopia Station*. Utopia, that venerable subject of philosophical thought, is a much-debated proposition with a mixed reputation. From its earliest incarnation, in Plato's *Republic*, through Sir Thomas More's eponymous book of 1516, it has represented an island of good social order, an ancient search for happiness, freedom and paradise. But by the twentieth century, its status as a topic for contemplation had taken a polemical turn. Theodor Adorno and other materialist thinkers derided it as a conceptual no-place ('no-place' being Utopia's literal meaning), a fantasy of an exotic vacation from insistent, plaguing social problems. It became a desert island of cliché. The contemporary Iranian film-maker Abbas Kiarostami, when asked if he had any unrealized or utopian projects, refused the idea of Utopia altogether, preferring to fix matters in the present, taking one hill at a time. If art is about dreaming up new possibilities, then how could one partially rehabilitate this category? Taking on this question, Nesbit, Tiravanija and I decided to set our sights on the middle ground, or station, between the island and the hill.

Utopia Station took shape as a conceptual as well as a physical

structure, a place and a non-place. It encompassed contributions from about sixty artists and architects, writers and performers, coordinated into a flexible plan by Tiravanija and the artist Liam Gillick. Gillick also put forward a very valuable critique of the concept of Utopia that guided us: 'The question for us,' he asked, 'is do we leave this utopian question to these people to fight over, or do we reclaim it through the use of analytical tools that are more rigorous at identifying the way things work? . . . why use such a flawed, dysfunctional, accusational tool for an exhibition title?' His answer was a suggestive non-answer: 'How could an exhibition like the one in Venice perform tasks of refusal in relation to the utopistic legacy while retaining some reconstituted sense of how things could be. In other words, how could it become a free-floating non-defined sequence of propositions that wander in and out of focus and avoid being lodged within the consumable world of the concept.'

Gillick and Tiravanija's plan comprised a long, low platform, part dance floor, part stage, part quay. Along one side of the platform was a row of large circular benches, so visitors could watch the happenings on the platform, turn their back, or treat their circle as a conversational pit. The benches were portable and one could also line them up like a row of big wheels. Along the other side of the platform was a long wall with many doors, some of which opened so visitors could investigate the other side of the wall. Some opened into small rooms containing installations and projections. The wall wrapped around the rooms and bound the ensemble into a long irregular structure. Over it floated a roof suspended on cables from the ceiling of the old warehouse where the Station was located. Outside the warehouse lay a rough garden into which visitors from the Station 'spilled'.

The Station itself was filled with objects, part-objects, paintings, images and screens. Visitors could also bathe in the Station, or sleep or daydream or picnic. In other words, the Station became a place to stop, contemplate, listen and see; to rest and refresh, to talk and exchange. Its programme of events multiplied and came to include performances, concerts, lectures, readings, film series and parties. They defined the exhibition as much as its solid objects did. People came and went, some eager to leave, others not sure what to say. These forms of doubt and tension, as pointed out by one of the artists, Carsten Höller, are as meaningful to a utopian project as certainty. The Station, then, produced a series of activities more complex than a mere exhibition, with many ideas and things recycled or put to various uses. It incorporated aesthetic material into another system that does not regard art as inherently separate from the world itself.

Utopia Station took place first in Venice, the city of islands, but it continued afterwards in other cities. It didn't require architecture, only a meeting, a gathering. We had several in Paris, in Venice, in Frankfurt, in Poughkeepsie, in Porto Alegre, in Berlin. As such, the Stations could be large or small. We maintained no hierarchy of importance between gatherings, meetings, seminars, exhibitions and books; all of them were and are equally good ways of working. There was no desire to formalize the Stations into institutions of any kind. When we met with the philosopher Jacques Rancière in Paris, he spoke about the difficulties in putting the idea of Utopia forward, because as an idea it had never interested him. What did interest him was dissent, the manner in which ruptures could be concretely created in speech, in perception and in sensibility. We should contemplate, he said, the means by which utopias can be used to produce such ruptures.

We organized one of our bigger Stations in Poughkeepsie, New York state, where Nesbit teaches at Vassar College. Just as a blizzard was about to blow in, the artist Lawrence Weiner reminded everyone that the artist's reality is no different from any other reality. Liam Gillick asked that we avoid a utopian mirage, and instead requested that Utopia become a functional step that moves beyond itself. Martha Rosler told the story of arriving to see the space in Venice as night fell, only to discover an interior of darkness. But Utopia, she said, is what moves. The film-maker Jonas Mekas warned us against an obsession with ideas, since dreams, he said, could only succeed if we forget about ideas. Anri Sala showed us a videotape of Tirana, in which the artist Edi Rama – then mayor of Tirana, and now prime minister of Albania – had painted the walls of an apartment block as a geometric vision, a sense of hope embedded – literally – in concrete. Our hero Édouard Glissant came. He spoke of the desire for the perfect shape. Only by passing through the inextricable, he told us, can we save our imagination. In that passing through would come what he calls the *tremblement*, the trembling that is fundamental to our passage.

The exhibition used Utopia merely as a catalyst to fuel other ideas. Consequently, it left any comprehensive definition of Utopia to others. Our aim was simply to pool our efforts, motivated by a need to change the landscape inside and outside, a need to integrate the work of many artists so that we might be integrated into a larger kind of community, a bigger conversation, another state of being. Each present and future contributor was asked to create a poster for use in the next Station and beyond; wherever it can hang, it can go. In this way *Utopia Station* evolves images, even if it does not start with one.

Each person who created a poster was also asked to make a statement of between one and two hundred words. The

statements mounted up. Stuart Hall and Zeigam Azizov elaborated on a proposition: the world has to be made *to mean*. 'The bittersweet baked into hope,' wrote Nancy Spero. Raqs Media Collective called Utopia a hearing aid. 'This probably will not work,' goes the Cherokee saying cited by Jimmie Durham, who added that the 'probably' is what keeps people alive. There were hundreds of statements like these in the end. They were all available to read anywhere via the website *e-flux*, an artist-run initiative founded by the artist Anton Vidokle, which has become a central information clearinghouse for the art world. Inevitably, certain figures began to be repeated: ships and songs and flags, potatoes, Sisyphus, figures familiar from the history of discussions of Utopia. *Utopia Station* became an archive of experimentation.

Ballet Russes

Utopia Station was an attempt to bring all the disciplines together. In this it followed in the footsteps of one of the greatest multi-disciplinary impresarios of the twentieth century, Sergei Diaghilev, creator of the Ballets Russes. The King of Spain once enquired of Diaghilev, 'What is it then that you do in this troupe? You don't direct, you don't dance, you don't play the piano, what is it you do?' Diaghilev answered, 'Your Majesty, I am like you. I don't work, I don't do anything, but I am indispensable.' Born to a wealthy Russian family in 1872, Diaghilev was the son of trained musicians. He loved music and singing, though he never reached a level where a professional career was possible. He had an early epiphany in St Petersburg while visiting Leo Tolstoy, the giant of the nineteenth-century Russian novel. Diaghilev became convinced that his future lay in the field of art, and he underwent a lengthy education in many artistic fields of endeavour.

Diaghilev studied law but became a critic and aesthete, starting a magazine called *The World of Art* in 1898. After the magazine folded, he began to curate large exhibitions under the same title. His interest lay in comprehensiveness: at the Tauride Palace in St Petersburg, for example, he curated a show of over 4,000 portraits by Russian painters. Much of his activity was based on an overwhelming capacity for socializing and friendship – through

curating he rapidly made contact with the luminaries of art, literature and music, and he retained many old friends for life. Out of this ferment Diaghilev was to make a parallel move from curating to the field of dance. Like Félix Fénéon's, his was a holistic approach to the arts that underwent many shifts over his lifetime. And like Fénéon, he has always been one of my greatest curatorial inspirations.

Diaghilev took a long time before coming to the ballet, his greatest legacy, where he created an unprecedented sensation in his time. Before this, in 1906 he curated a show of modern Russian art which travelled throughout Europe, and he made his first trip to Paris. He then became fascinated by opera and ballet, seeing them as a modern form of *Gesamtkunstwerk*. Although ballet had reached a high point in nineteenth-century Russia, it was not yet a celebrated art form. Nevertheless Diaghilev poured his energies into promoting it from 1909, when he founded the Ballets Russes, producing twenty years of ballet performances amidst wars, crises and social turmoil, until his early death in 1929. Often beginning a new season with no money in his pocket, he was a master of cajoling and cadging investment from every quarter to realize his grandiose ambitions. He introduced the short-format, half-hour ballet, and began the practice of commissioning major composers to write original work for it. He also provided a major stimulus to the art of choreography by demanding innovation. Diaghilev turned the commissioning of new works of art into a recognizable form of producing reality, hugely expanding the scope of ballet by inviting the greatest artists, composers, dancers and choreographers of his time to collaborate on the extraordinary ballets his company produced. His visionary productions created a twofold effect. On the one hand, he brought the best international artists to the Russian stage. On the other, he

brought the Russian avant-garde to the attention of the larger Western world, both by curating exhibitions of Russian art early in his life and later through the global tours of his ballet company. Most of all, Diaghilev and his ballets were the toast and sensation of fashionable and artistic Paris. His productions had an effect on other artistic movements – for instance, Fauvist painting is often understood to have been influenced by his productions' use of colour. In his time, he was the most famous theatrical producer alive, and yet Diaghilev's work exceeds any description that limits his influence to the theatre or dance. As his biographer, Sjeng Scheijen, has written, 'The labels customarily attached to him – those of impresario and patron – fail to do justice to the powerful influence he exerted on the arts in the early part of the twentieth century. His goal of developing his own variant of the Wagnerian *Gesamtkunstwerk*, without ever really producing creative work of his own, makes it difficult to place him or assess the value of his achievements.'

Diaghilev's was a completely interdisciplinary form of curating, although it was not recognized at the time by that name. He was, first and foremost, a collector of artistic sensibilities, befriending a young Pablo Picasso and collaborating with Georges Braque and Natalia Goncharova. His mentors and advisers included literary giants such as Oscar Wilde, and he invited Anton Chekhov to edit a literary journal. In music he promoted and worked with Igor Stravinsky – whom he commissioned to write *Le Sacre du Printemps* – Sergei Prokofiev and Claude Debussy, among many others, and in dance he worked with such towering figures as Nijinsky and George Balanchine. He also commissioned Coco Chanel to make costumes for him.

For Diaghilev, the artistic world was promiscuous – his work brought together the giants of each contemporary field in order to create unexpected productions. In so doing, he joined many

worlds to create a larger one. Perhaps his most characteristic statement of what he sought from these collaborations was his injunction to Jean Cocteau: '*étonnez-moi!*' ('dazzle me!'). The toll his exhausting work ethic took on him, however, led to illness and death at the age of only fifty-seven. Diaghilev died in Venice, as the musician Nicholas Nabokov wrote, 'in a hotel room, a homeless adventurer, an exile, and a prince of the arts'.

Time and Exhibitions

On 1 January 2000, I was speaking on the phone with Matthew Barney and he mentioned something interesting: there was, he said, a new hunger amongst artists for live experience. This phone call stuck with me as it has proved prophetic, because artists ever since have increasingly been experimenting with live situations. Gradually I developed a project around this new hunger with Philippe Parreno. Parreno had explored the notion of time and exhibitions in an essay called 'Facteur Temps' ('Postman Time'). He pointed out that visual art ordinarily does not dictate the time a visitor must stand in front of it. In fact, this is one of the defining characteristics of art in museums and galleries: it allows visitors to have control over their time. They can stand in front of Manet's *Déjeuner sur L'Herbe* for ten seconds or two hours, making their own judgements as to how long the painting deserves their attention. Rarely does visual art behave in the way theatre does: by dictating time. However, an exhibition that functioned in this manner would expand the ways in which visual art has historically been understood: a time-bound visual group exhibition would, in effect, be a new experience.

Over several years of conversation, Parreno and I discussed bringing artists together to do a time-based group show: the rule of the game was that instead of giving each artist *space* in a museum or gallery, we would give them an allotment of *time*.[11]

We assembled a group mostly from the generation of artists who had been thinking about and working on the issue of time: Doug Aitken, Matthew Barney and Jonathan Bepler, Tacita Dean, Thomas Demand, Trisha Donnelly, Olafur Eliasson, Peter Fischli and David Weiss, Liam Gillick, Dominique Gonzalez-Foerster, Douglas Gordon, Carsten Höller, Pierre Huyghe, Koo Jeong-A, Anri Sala, Tino Sehgal and Rirkrit Tiravanija, with Darius Khondji and Peter Saville, and music conducted by Ari Benjamin Meyers.

Together we conceived of the idea of a visual art opera, in which each artist would be responsible for a set amount of time during an evening at the Manchester Opera House. With the festival director, Alex Poots, we invited the artists to Manchester in 2007 for the MIF (Manchester International Festival) and developed a score for the evening. The idea was that, like an opera or an exhibition, the score would allow *Il Tempo del Postino*, as we called the event, to be replayed – and it was, in Basel two years later – but never in exactly the same way.

It was a very polyphonic situation, and continued changing up to the last minute – had we arranged it all beforehand, it risked becoming a dead situation. A few examples of the works performed: Liam Gillick's piece opened the show and recurred at each of its intervals; in it, a player piano onstage played a song. But rather than a perfect piece of sheet music, the piano's source music was a transcription of Gillick's imperfect attempt to play, from memory, a Portuguese revolutionary song he had heard once, long before, at the birthday of a friend. Pierre Huyghe's piece appeared interstitially between the others, in the form of three segments. In it, a troll and a large yellow monster fall in love. Tino Sehgal had the orchestra play a symphonic arrangement of 'Aerodynamic', a song by Daft Punk, the French electronic musicians. To this music, the stage curtain danced. This was achieved by two dancers, who, like puppeteers,

skilfully manipulated the cords controlling the curtain's rise and fall according to a choreography devised by Sehgal.

Anri Sala, meanwhile, used *Vogliatmi bene un bene piccolino*, an aria from *Madame Butterfly*, to connect live opera to the sound technology of cinema. 'I wanted to do something related to voice,' he told me. 'My idea is to re-enact the same aria but instead having one butterfly, to have seven butterflies, and instead of one Pinkerton, to have two Pinkertons. Five of them will be on stage, a distribution that we have in cinema in Dolby surround, where you have five different points in the space, and take two for Pinkerton, like a stereo.' The intriguing combination of live and recorded methods, Sala said, came because he 'felt desire for unmediated experience growing. It's about how to be able to edit things in real time, instead of editing things when you edit a film. And also, to play with this magical moment that comes.'

Tacita Dean wanted to create an episode of silence. She paid homage to one of the twentieth century's most famous compositions, John Cage's 4'33", in which no music is played. Dean filmed Merce Cunningham for the four minutes thirty-three seconds duration of Cage's 1952 piece. The elderly Cunningham, an explosive and kinetic choreographer and dancer, simply sat still, shifting positions slightly for each of the composition's three movements. It echoed the power of Cage's 'silent' piece of music. Dean's film was projected onto a screen on the stage such that Cunningham's image appeared the same size as the audience watching him. He could have been the ghost of the event.

Matthew Barney produced a collision of narratives from Celtic and Egyptian myth, drawn from his own *Cremaster* series of films. For Barney, the project was a chance to restore the productive failures that the film-making process is designed to edit

out. 'In the course of editing,' he said, 'you remove the failure, which in a way takes away something that was very magical. Everything that happens in post-production, that kind of kills that moment.'[12] The difficulty and the beauty of a live work, for Barney, had to do with his inability to remove such moments of failure.

During the intermission, Barney had a group of musicians dressed as military personnel marching through the foyer, and then the theatre, ending up on the stage. They carried a young girl on a stretcher. The orchestra played a score created by Jonathan Bepler, Barney's collaborator. The house lights remained on. The girl was deposited on top of a dilapidated car, while a tableaux of dancers in Egyptian costume and guards in New York City sanitation uniforms attended the scene. A live Scottish bull was present, lending a Celtic aspect to the proceedings but also a symbol of Egyptian fertility rites. Barney himself played a funereal prince, wearing on his head a basket containing a small Egyptian dog.

In Trisha Donnelly's sequence, singer Helga Davis took to the stage and began to sing to a beat played in the wings by Donnelly herself, who held and rhythmically pulsed metal percussive bells. After several minutes of sound came a flash, the screen filled with an image of Gary Cooper, and the chorus sang lowly in surprise, 'Whoah . . . Gary Cooper.' Then the song resumed, four massive black obelisks toppled on stage, Davis walked into a cube of blue light, and the orchestra stood and vocally resonated with the sound. Smoke and dark shapes billowed. Rirkrit Tiranvanija created a puppet show of ventriloquists' puppets sitting on the laps of three sisters, who sang as the puppets mouthed the lyrics. The piece by Koo Jeong-A was the shortest in time: in very dim light, the curtains opened to reveal a very large tree onstage, its leaves rustling in a faint breeze. After one minute, the curtains closed and the piece ended.

The sheer variety of the different works was intriguing. Art is not linear, and the impact of such experiments are often not picked up the next day. But they sink in; such projects have an immediate effect but they also have a long-term effect. Exhibitions, I have noted, always plant seeds. Maybe in five or ten years a young artist will emerge whose talents were triggered by that show.

Live art, self-evidently, moves away from the idea of art as the production of material objects. I learned from my long-ago conversation with Eugène Ionesco that a work like his play *La Cantatrice chauve* – which ran every night for forty years – could be as permanent as any work in bronze or marble. In this sense live art can also be sculptural. A key inspiration here is the duo of Gilbert and George, who, more than any other artists, have explored this idea. They made a series of works in which they appeared themselves, as living sculptures, opening up a new form of artistic practice as a result.

The Manchester International Festival, the idea for which came from the graphic designer and artist Peter Saville, has a tirelessly innovative artistic director, Alex Poots. Under his direction, the festival has become one of the primary places in the world to experiment with live art. *Il Tempo del Postino*, in 2007, was our first such experiment. For the 2009 festival, we collaborated with Manchester's Whitworth Gallery and its director, Maria Balshaw, to create *Marina Abramovic Presents*, in which visitors were given lab coats and taken through a collective drill by Abramovic herself, before being left to wander through the gallery. In 2011, the idea of living sculpture coalesced into *11 Rooms*, an exhibition I curated with Klaus Biesenbach for the festival and the Manchester Art Gallery. Each year it grows by a room – its most recent iteration (in 2013) was *13 Rooms*, in Sydney.

Our idea was to do 11 *Rooms* as a show in a traditional museum rather than a performance hall or a theatre. The exhibition comprised a series of eleven rooms in the Manchester Art Gallery, in each of which visitors encountered a live situation. Every one of the eleven artists we invited was allotted a room in which to develop an instruction-based piece. And rather than happening over one evening, as with theatre, these pieces were enacted non-stop during the opening hours of the museum for the duration of the exhibition. At the closing of the museum each night, the human sculptures went home.

Once again the variation was rich: for the first occasion, we invited eleven artists who had been working on various non-object-based projects: John Baldessari, Tino Sehgal, Roman Ondák, Marina Abramović, Joan Jonas, Allora y Calzadilla, Lucy Raven, Santiago Sierra, Simon Fujiwara, Xu Zhen and Laura Lima. In one room, Ondák installed a piece called *Swap*, in which a person sitting at a table behaved rather like an auctioneer. He or she invited the visitors to the gallery to bargain for a small object on the table, in exchange for something they had on their person. They exchanged objects such as a small bottle of perfume, a lunch voucher, a deck of playing cards, a map – even, in one instance, a bottle of olive oil.

In the 1970s, John Baldessari had proposed a work in which a corpse would be displayed in a gallery, but made up as though it were a wax, or a realistic sculpture of the human body. Most live works take the form of a kind of *tableau vivant*, whereas Baldessari's was a *tableau maudit*, a tableau of death. We tried to find a hospital, a medical school, a bequest, or any way we could procure authorization to realize Baldessari's idea for 11 *Rooms*, but were ultimately unsuccessful.

In another room of the show Joan Jonas remounted her piece *Mirror Check* (1970). A naked woman, after entering the small

room and taking off a robe, begins to examine her body with a compact, handheld mirror. And in yet another room Marina Abramović recreated, using a performer, her work *Luminosity* (1977), which displays a woman on a bicycle seat mounted high on the wall, in a pose something like a crucifixion.

In Tino Sehgal's 11 *Rooms* piece, titled *Ann Lee*, visitors were confronted by a live protagonist of around twelve, with the distinctive fringe and hair tucked behind her ears that seems the only common feature to all previous iterations of Ann Lee. Moving slowly and eerily, the protagonist introduced herself as Ann Lee and explained her origins in a manga comic book, and as an animated character in videos by Pierre Huyghe and Philippe Parreno. She explained that it had always frustrated her to be stuck in a comic book or videos, unable to talk to visitors in museums, and so she had decided to come to life, posing questions and riddles to the visitors.

Of Pavilions and Marathons

In 2006, I moved to London to work with another inspirational figure, Julia Peyton-Jones who I was introduced to by the artist Richard Wentworth. Having begun as an artist herself, Peyton-Jones became director of the Serpentine Gallery in 1991. At the time, it was a rather quiet gallery housed in a former tea pavilion in Kensington Gardens. She quickly began to transform it into a very dynamic place where the newest and most forward-looking art and artists could be exhibited. Peyton-Jones and I collaborated for the first time in 1996, when she invited me to curate an exhibition at the Serpentine called *Take Me (I'm Yours)*, in which artists made works that the visitors could take home, influenced by the work of Felix Gonzalez-Torres.

Peyton-Jones has built the Serpentine into a global institution. She first began to build up its programmes, beginning new curatorial initiatives, research projects, and developing support for more and more ambitious exhibitions. She has been unafraid of taking on collaborators – another favourite adage is 'one plus one equals eleven', and I believe that together we have become an effective example of how an institution can be run through co-directorship. A second building – the Serpentine Sackler Gallery – designed by the architect Zaha Hadid, was recently opened a short distance away from the original gallery – the cord that links the two spaces is a walk across the park.

Peyton-Jones has been emphasizing the gallery's setting in the park for many years. In 2000, she had the idea of a temporary pavilion for the Serpentine, and invited Zaha Hadid to design it; Peyton-Jones then expanded this into a yearly programme, using a simple rule: only architects who had not yet built anything in the UK could be chosen. The programme is a combination of urbanism, architecture and exhibition, and gives the public a chance to experience the work of a globally important architect. Each summer, the pavilions draw tens of thousands of visitors to Kensington Gardens.[13] By the time I joined Peyton-Jones at the Serpentine in 2006, these seasonal, outdoor architectural structures seemed to be a great opportunity for new types of content to fill them during their temporary lifespan. We also wanted to give the city an image of itself in a temporary structure. We began to think about content that might play some of the same roles as an open-air music or theatre festival: somewhere you could wander around, see or hear or experience something, then wander off and have a meal, or coffee, or fall asleep in the park, and then return for more.

Around the same time, I was working on the Theatre of the World festival in Stuttgart. Thinking about what could happen on the stage there, I had the idea of simply distending a conversation in time, into a conversation marathon composed of many conversations. The intention was to create a kind of portrait of Stuttgart. I felt we could address how one can map a city and its constituent parts by means of a series of conversations with the people there – artists, architects, theatre directors, scientists, engineers and so forth. So we organized a conversation lasting twenty-four hours, a conversation marathon, and we came up with quite an incredible list of practitioners to participate.[14]

Back in London with Peyton-Jones, we put her invention of the Serpentine pavilion series together with my conversation

marathons. In 2006, Peyton-Jones and I commissioned a pavilion from Rem Koolhaas and Cecil Balmond, for which we wanted to create an event. In addition to curating art, architecture and science, for example, we wanted to see whether we could also curate conferences – in other words create new rules of the game for the field of conferences. From that impulse, the Serpentine Marathon was born, as a kind of twenty-four-hour polyphonic knowledge festival where all kinds of disciplines meet. And so Koolhaas and I invited many different speakers, and the programme culminated after the twenty-four hours. We didn't go to sleep but stayed onstage for the duration and spoke to seventy-two Londoners. It was an attempt at making a portrait of the city and it concluded with an urgent ecological message from Doris Lessing, which completed the Marathon.

Normally, when you invite somebody from the architecture world to give a talk, it's mostly the architecture crowd that attends; when you invite somebody from the art world, the art-world types attend. Each speaker attracts a particular audience to his or her field of interest, yet there's little crossover. But through the twenty-four-hour Marathons, it's possible to cross and combine disciplines a bit: as a visitor you could turn up at three in the morning to listen to a range of people and even after that you might stay on to listen to an interesting young graphic designer. That then leads to something else, and the whole experience moves beyond particular disciplines to involve the city itself.

The Marathons developed into a series and the year after making the first pavilion with Koolhaas and Balmond, a Serpentine pavilion was created by Olafur Eliasson and Kjetil Thorsen. Eliasson thought that the year before there had been so much talking, and it would really be better now to *do* something, so we stopped talking and we did an Experiment Marathon. That

changed the format itself – the Marathons were no longer strictly interviews, but hybrid combinations of conversations, performances, presentations and experiments. They became, essentially, time-based exhibitions. As their name suggests, they are essentially temporal rather than spatial experiences.

The year after that, in Frank Gehry's pavilion at the Serpentine, we were inspired by Speakers' Corner in the northeast corner of Hyde Park. Traditionally, Speakers' Corner is the place in London reserved for anyone to get up on a soapbox and speak, where members of the public have a forum to deliver radical lectures, speeches, manifestos, denunciations, appeals, rants. Today, of course, this happens mostly on the Internet, but Speakers' Corner is still a vibrant place for debate. Manifestos, of course, have played a major part in the history of art, and we thought it would be interesting to do a Manifesto Marathon, for which we invited sixty-seventy participants to produce a manifesto. Because we are living in a time that is more atomized, artistic movements are less cohesive, which raises the question: are manifestos still relevant? Or, maybe unilaterally prescribed manifestos are very twentieth century, and the twenty-first century is more like an exchange.

The year after, in SANAA's pavilion at the Serpentine, we hosted a Marathon about poetry. Especially in this age in which the market plays a much bigger role in the art world than ever before, I thought it was important to look at the world of poetry. All the great avant-gardes of the twentieth century had connections to poetry. It is fundamental to culture. And so we invited poets and artists to read poetry. The year after that, we thought it would be interesting to find a theme that connected to technology. Since my first meeting in 1986 in Rome with Alighiero Boetti, who was making his world maps, I had been fascinated by the fact that maps play such a large role in the contemporary

art world. Like Boetti, many artists are obsessed with maps. I suddenly realized that maps, and the whole idea of navigation systems, have become, along with social networks, one of the biggest topics on the Internet. So we brought together artists, web designers and architects to think about mapping in the twenty-first century.

In 2011 we commissioned a Serpentine pavilion by Peter Zumthor with a garden by Piet Oudolf, who created the floral displays for architects Diller Scofidio + Renfro's High Line park in New York. Over many conversations we started to think that maybe the theme here should just be the garden itself. The garden, of course, is an idea with which so many artists, architects, poets and novelists have been obsessed, from ancient Greece's Arcadia, to the Islamic world's majestic gardens, to the British landscape designer Capability Brown, to the writings of Hélène Cixous on gardens as cemeteries, to modern landscape architecture. The German author and film-maker Alexander Kluge once told me that the medieval concept of the *hortus conclusus*, or enclosed garden, performed many of the same functions as an exhibition. Equally, it's a very relevant notion with regard to the Internet. As Kluge wrote in his text for our catalogue, the Internet is a garden of information. Eventually, for our Serpentine pavilion Zumthor built a simple, monastic cloister, a *hortus conclusus*, where people could sit in contemplation within Oudolf's garden. Can there be such a thing as a cloister on the Internet? To try and answer that question, in October 2012 we invited sixty-seven participants from all fields, as part of a Marathon, to discuss the following idea: what counts as a garden in the twenty-first century?

The Marathons are not only about the here and now, but about the present in terms of memory, a 'protest against forgetting' in the historian Eric Hobsbawm's phrase. During an

interview I conducted with Hobsbawm in 2006, he raised the idea of organizing an international protest with this aim in mind. It's a beautiful idea and so we organized a Memory Marathon in October 2012, centred on Herzog & de Meuron and Ai Weiwei's pavilion. They had produced a pavilion of archaeology and memory, a refuge for thinking. Hobsbawm died on 1 October of that year, and the Memory Marathon was unofficially dedicated to him.

Curating (Non-)Conferences

In 1993, the art historian Christa Maar invited me to the *Akademie zum 3. Jahrtausend* (*The Academy of the Third Millennium*). She wanted to involve curating in the Academy, which was very interdisciplinary and conflated neuroscientists with architects, artists and thinkers. That is how my dialogues with science began. One of the first conferences of the Academy evolved around intersections of the brain and computers. There I was first introduced to scientists alongside intellectuals and cultural thinkers, like the neuroscientists Francisco Varela, Ernst Pöppel and Wolf Singer, or science-fiction writers like Bruce Sterling. Christa Maar also introduced me to John Brockman in New York. All of the above is closely connected to his *Third Culture* and *Edge* approach to leave the 'two cultures' described by C. P. Snow behind and to consider culture more expanded. Brockman is interested in 'the edges of culture', as he told me in our first meeting. Having suddenly been introduced to such an interdisciplinary mixture of people was like a revelation to me. So I thought more about how to connect the arts and the sciences within my own curatorial work.

In 1995, Maar asked me to organize something relating to art and science for the conference *Mind Revolution*. I wasn't sure what exactly to do, but my sense was that to force artists and scientists to collaborate felt wrong. That would be to dictate

the production of new works in a rather authorial way. Instead, I thought it could be more interesting, and more unpredictable, to produce a context for chance encounters. Reflecting on the conferences I had already attended, I realized that the conjunction of scientists, artists and others was productive in and of itself. Often, however, the most interesting encounters didn't occur during the official panel discussions, with their typical format of a presentation perhaps followed by a short question-and-answer session, but instead in the green room, cafeteria or restaurant where the participants went before and afterwards. Simply bringing interesting people together in a specific place and time was in and of itself the crucial thing. The coffee break, it appeared, was perhaps the most urgent, yet invisible, meeting point or junction at the conference.

Unlike exhibitions, which have been transformed throughout the twentieth and early twenty-first century, symposia, conferences and panel discussions have followed a very standard lecture or round-table discussion. So I thought it would interesting to apply the idea of changing the rules of the game for a discursive event like a conference, similar to what I had done in exhibitions. A mischievous idea occurred to me. What if one had all the accoutrements of a conference: the schedule, hotel accommodation, participants with their badges, but dispensed with the 'official' elements of panels, speeches, plenary sessions and so on?

I suggested that we invite artists to Ernst Pöppel's research centre near Cologne, in Jülich, where there were hundreds of scientists and laboratories. The idea was to create a contact zone where something could happen but nothing had to happen. And so the 'conference' we organized at the research centre, 'Art and Brain', had all the constituents of a colloquium except the colloquium. There were coffee breaks, a bus trip, meals, tours of

the facilities, but no colloquium. The artists made their contacts, and having made them, they could go into town to produce works and collaborate with the scientists. At the end we made a little film, where everybody spoke about their impressions, and published a set of postcards. Now other activities are developing at the research centre without any need for more centralized organization.

Just as Cedric Price always talked about the importance of the 'non-plan' in architecture, 'Art and Brain' was something of a non-conference. Once again, the role of the curator is to create free space, not occupy existing space. In my practice, the curator has to bridge gaps and build bridges between artists, the public, institutions and other types of communities. The crux of this work is to build temporary communities, by connecting different people and practices, and creating the conditions for triggering sparks between them.

Several years later, in 2003 in Japan, I worked with Miyake Akiko to organize a conference called *Bridge the Gap?* at the CCA Kitakyushu, an art centre and school. The idea was to continue the 'Art and Brain' 'conference' but on a larger scale. The Chilean biologist Francisco Varela, who had been one of my scientific mentors, had recently died, and so we started with the idea of inviting some of his friends and colleagues. We also invited a lot of other artists, scientists and architects.[15] We were interested in delinking our group from the world, to give them time and space, and so the location of the conference, at a remote house on the outskirts of Kitakyushu, became an asset. Participants had to fly to Tokyo, then take an internal Japanese flight, then an hour-long car ride. Finally, they arrived at a very old Japanese house, which was so remote that they couldn't easily get away again.

For three days we brought this group of incredibly busy

people to a literal standstill. Normally they would give their lecture and immediately leave for their next appointment, meeting, and so on. In Kitakyushu we had rooms for official meetings, and also – inspired by online chat rooms – rooms for self-organized chats between participants. (There were a lot of rooms in the house.) The house also had a traditional Japanese garden, which allowed them to stroll outside. And we installed a reading room with all the published books by all the speakers, so if you met or heard an interesting person, you could find their books in the reading room. The speakers ranged from Rem Koolhaas and Marina Abramović to the mathematician Gregory Chaitin. Another talk was by the quantum physicist Anton Zeilinger, who was researching a mystery as inexplicable as any in the arts: how subatomic particles can become 'entangled' or linked to each other no matter how much distance comes between them. The whole experience was a bit like a salon for the twenty-first century.

In 2005, Hubert Burda, Steffi Czerny and Marcel Reichhart began an organization called DLD. It very much brings the different worlds together on a continuing basis, bridging digital innovation, life science, the arts, design and urbanism. Yet, it is not just a mere conference: it is really about the production of reality, about connecting people who otherwise wouldn't have encountered this way within the frameworks of knowledge production. As J. G. Ballard would say, it is about 'making junctions'. Steffi, who connects practitioners from different disciplines in a wonderful and unique way, invited me to curate the DLD Arts section.

Each year has a different rule of the game and a different topic: *Parallel Universes* (2007) scrutinized alternative and extended ways of arts, *Archives and Memory* (2008) dealt with archival work and memories. *A Black Mountain College for the 21st*

Century (2008) discussed new models of interdisciplinary art schools and education. *Maps for the 21st Century* (2009) evolved around how the notion of location has changed with the advent of the internet and mobile displays. *Ever Clouds* (2010) focused on cloud theories, concepts and digital cloud architecture. *Solaire Solar* (2011) developed around conversations between Tino Sehgal, Olafur Eliasson and Frederik Ottesen to build a solar aeroplane. *Lights on Africa* (2012) focused on energy in off-grid areas and a pre-launch of Eliasson's 'Little Sun' project. Both the *Ways Beyond the Internet* (2012) panel and exhibition explored the concept of 'Postinternet' with emerging artists, who grew up with the internet as an everyday condition. All of these conversations brought together artists, architects, scientists and digital-culture thinkers. Reaching out to different worlds to connect them means going beyond the fear of pooling knowledge, something I think will become increasingly important as disciplines become ever more specialized.

Les Immatériaux

The bridges between science and art lead me to *Les Immatériaux*. It is difficult to write about an exhibition that one has not seen or experienced in person. But I need to make an exception for *Les Immatériaux*, organized by the French philosopher Jean-François Lyotard with Thierry Chaput, director of the Centre de Création Industrielle, because it is necessary to underline its importance. This exhibition has in many respects also been a catalyst for artists with whom I have had close working relationships over the years, such as Dominique Gonzalez-Foerster, Pierre Huyghe and Philippe Parreno, all of whom saw the exhibition when they were art students and continue to discuss it to this day.

Les Immatériaux was shown between 28 March and 15 July 1985, on the fifth floor of the Pompidou Centre in Paris. It was one of the first exhibitions to anticipate our digital future *avant la lettre*. At its core, it aimed to investigate the consequences of the shift from material objects to immaterial information technologies, or, perhaps in a sense, the shift from modernism to postmodernism. Indeed, the exhibition's title may be translated as 'Immaterials' or 'The Non-Materials', reflecting for Lyotard not just a shift in the materials we use, but also in the very meaning of the term 'material'. For the exhibition design, Lyotard conceived an open, labyrinthine *parcours* with one entrance and one exit but multiple possible pathways through. Walls were

not solid structures but rather grey webs that stretched from floor to ceiling. Visitors wore headphones and listened to radio transmissions that came in and out of focus as they moved through the space. Such fluid nonlinearity exemplified the very conditions of immateriality central to the exhibition's argument. The multiple pathways led to around sixty 'sites', as Lyotard called them, which were dedicated to different subjects and questions, from painting to astrophysics.

As Lyotard explained in the exhibition catalogue: 'We wanted to awaken a sensibility, certainly not indoctrinate minds. The exhibition is a postmodern dramaturgy. No heroes, no myths. A labyrinth of situations organized by questions: our sites . . . The visitor, in his solitude, is summoned to choose his way at the crossings of the webs that hold him and voices that call him. If we had answers, a "doctrine", why all this trouble?' For each of the different sites, Lyotard combined in various displays artworks, everyday objects, technological devices and instruments of science. In this respect *Les Immatériaux* (though I know it primarily from the catalogue and accounts of those who saw the exhibition) has influenced my projects on the relationship between art and science – both, for Lyotard, share a sense of *astonishment*. *Les Immatériaux* also inspired me to think about making exhibitions that are interdisciplinary.

The catalogue of *Les Immatériaux* is a rich toolbox. It is roughly the size of a magazine, with a grey cover on top of a slip case containing seventy-two loose sheets of paper. Each site and topic in the exhibition is represented by one sheet. Additionally there are some explanatory sheets, including the exhibition plan and texts by Lyotard. Just as the exhibition did not have a fixed *parcours*, and each visitor could explore his or her own path, the sequence of these loose sheets could always be rearranged while reading. The catalogue is not didactic and linear,

but rather is intended to be read in a nonlinear way. Its format inspired my exhibition *Cloaca Maxima* in Zurich in 1994, for which we also designed the catalogue as a slip case.

Another philosopher who ventured from philosophy to curating is Daniel Birnbaum. Philosophy, as Birnbaum says, regularly goes into exile. It needs another discursive field to develop its concepts and to make them productive. Jean-François Lyotard talks about this in terms of a diaspora of thought wandering through other domains. In the 1960s this external sphere was no doubt primarily society itself, and much of philosophy took place in proximity to sociology. Furthermore, in the 1970s new ideas about the text and textuality became so fashionable that philosophy seemed to merge with a novel kind of high-strung literary criticism.

In the 1980s ideas about the simulacra of the media turned the dialogue with art and the world of images into the liveliest point of departure for philosophical exploration. What happened then? Through what new domains has philosophy wandered since? Technology, the city, architecture, forms of globalization. Yes, no doubt through all of these areas, and perhaps also through the exhibition as a medium for thought and experimentation. This curatorial turn of radical thought materialized for the first time in Lyotard's *Les Immatériaux* exhibition, which in 1985 anticipated two decades of frantic exhibition production across the globe. *Les Immatériaux* was a large experiment about virtual reality and about the exhibition itself as a work of art. Lyotard was fully aware that this was a very provocative concept.

Les Immatériaux was followed by several other exhibitions curated by philosophers and scientists: Jacques Derrida's *Memoirs of the Blind: The Self-Portrait and Other Ruins* (1990–91) and Julia Kristeva's *Visions Capitales* (1998), both held at the Louvre

in Paris; or, more recently, Bruno Latour's *Iconoclash* (2002) and *Making Things Public* (2005) at ZKM, Karlsruhe, Germany. *Les Immatériaux* changed the landscape not only for exhibition-makers, philosophers and scientists, but for artists as well. Here is Dominique Gonzalez-Foerster's recollection of experiencing the show:

> *Les Immatériaux* was a truly memorable exhibition. Strangely enough, my most memorable experiences have been in environ-ments, complete environments . . . rather than exhibitions per se . . . What I think was really beautiful in *Les Immatériaux* was the exploration of all the dimensions of light and sound by means of infrared and text. The viewer's movement was taken fully into consideration. For all those reasons, it was actually a very important exhibition.

Philippe Parreno once told me:

> If you haven't seen the exhibition, it's hard for me to describe it. If I tell you how it was, it will sound like a dream. The show was surprising in the curatorial choices, in the manner in which objects and experiences were arranged. It was superb . . . *Les Immatériaux* was an exhibition producing ideas through the dis-play of objects in a space. It was very different from writing a book or developing a philosophical concept. And that's precisely what I loved in that exhibition.

Gonzalez-Foerster and Parreno studied at the Institut des Hautes Études en Arts Plastiques in Paris, which was founded by Pontus Hultén, Daniel Buren, Serge Fauchereau and Sarkis in 1985. Hultén once invited Lyotard to the institute. During this

discussion, Lyotard spoke about his concept for a second exhibition, this time on the topic of resistance. This exhibition was not realized, but Parreno, who was present at that discussion, never forgot about it: 'Lyotard wanted to do another exhibition, "Resistance". "Resistance" isn't a good title. You immediately think about a series of moral issues. But when I met him, I understood that he meant in fact resistance in another way. In school when you study physics you are told that frictional forces are not important – the forces of two surfaces in contact let certain axioms become uncertain. I think that's what "Resistance" was supposed to be about.' Whereas *Les Immatériaux* was an early reflection of the Internet age, 'Resistance' would be about the opposite: that in our age of many connections, resistance is also necessary.

Parreno, Birnbaum and I now plan to realize Lyotard's unrealized idea at an intriguing site: an art centre being created by art collector, producer and patron Maja Hoffmann's LUMA Foundation. Hoffmann invited the artists Liam Gillick and Philippe Parreno, and the curators Tom Eccles, Beatrix Ruf and myself, to form a group with her to plan an experimental art centre far from any big city, which will be designed by Frank Gehry. It's in Arles, in the marshland of France's Camargue.

Hoffmann's goal is to connect the centre to ecology. So, in 2012, we took a step towards that goal by creating an exhibition called *To the Moon via the Beach*, which took place in the Roman amphitheatre of Arles, a historical site popular with tourists and often used for bullfighting and festivals. Following an idea of Parreno and Gillick's, the amphitheatre was in transformation for the duration of the exhibition. At the start, visitors encountered an arena covered in tons of sand. This terrain was transformed from a beach to a moonscape by a team of sand

sculptors and also acted as the backdrop to a series of interventions from twenty artists, who guided visitors, reacted to the shifting landscape and produced works in and around the arena.

At the end, all the sand was moved to Arles's Parc des Ateliers, a former railway construction site, where it will be accessible to the public as part of a temporary playground. It will then be re-used once again in the foundations of the forthcoming LUMA centre – a new creation, production, exhibition centre, specializing in contemporary art. As the philosopher Michel Serres says, perhaps part of today's fundamental evolution of art could be to open oneself up to living species, to open up to life and to nature.

Laboratorium

In-betweenness, as the critic Homi Bhabha has written, is a fundamental condition of our times. This is an especially useful principle for my exhibitions involving science, where the idea has always been to produce an in-between space that allows for radical and unexpected combinations.

Laboratorium, which I curated with Barbara Vanderlinden in 1999 in Antwerp, was an interdisciplinary project in which the scientific laboratory and the artist's studio were explored on the basis of the various concepts and disciplines they used. It was an attempt to create a bridge between the specialized vocabularies of science and art and the general audience, between the expertise of skilled practitioners and the concerns and preconceptions of the interested public. Throughout that summer in Antwerp, we established networks between the people of Antwerp and communities of scientists, artists, dancers and writers. To give access to all these communities, we provided visitors with maps and bicycles to explore for themselves.

We started with a method that is often used for historical exhibitions, but too rarely for contemporary ones: we created a think tank to develop ideas. This included different people with affinities to our organizing principle, like the artist Carsten Höller who trained as a scientist. The discussion revolved around questions such as the following: How can we attempt

to bridge the gap between the specialized vocabulary of science, art and the general interest of the audience, between the expertise of the skilled practitioner and the concerns and pre-conceptions of the interested audience? What is the meaning of laboratories? What is the meaning of experiments? When do experiments become public and when does the result of an experiment reach public consensus? Is rendering public what happens inside the laboratory of the scientist and the studio of the artist a contradiction in terms? These and other questions were the beginning of an interdisciplinary project starting from the 'workplace' where artists and scientists experiment and work freely.

Laboratorium brought the philosopher and historian of science Bruno Latour to the exhibition format. Latour's work contains insights about the networks of meaning developed in particular institutions, governing the kind of knowledge they generated – for instance, a hospital is a particular social space with its own rules, expected behaviours, protocols, nomen-clature and web of relationships. The individuals circulating through these spaces form social networks, which generate particular ways of being. It struck us, of course, that science and art often emanate from a particular social space – that of the *laboratory* and the *studio* respectively – and so an idea began to develop that involved making a junction between the two. Thus, to enact this expansive understanding of the ideas behind *Laboratorium*, we spread the show out into Antwerp at large.[16]

Latour came up with a brilliant concept for *Laboratorium*. He devised a lecture series called 'The Theatre of Proof', in which he would recreate important experiments from history. Latour's intent was not to do historical re-enactments in order to cele-brate and popularize past scientific successes, but to grapple with the difficulty of understanding and interpreting what an

experiment means and says. Also, the fact that the materials needed for many famous past experiments are no longer available is a problem – as the chemist Pierre Laszlo pointed out, showing how difficult it is to gather materials for even classic chemical experiments of the past. Experiments, as Latour well knows, only have an effect when they are *publicized*. Therefore, staging them in public raised another layer of difficulties: attempting to translate what happens inside a closed room to the world beyond.

Isabelle Stengers, a philosopher of science, gave a great example of this by curating a space devoted to Galileo's experiments with billiard balls rolling down inclined surfaces; Galileo carried out these experiments while formulating the law of falling bodies, which governs how and why the planets move. In her lecture Stengers asked whether painstaking experimentation with the balls had generated the law, or whether Galileo had conceptualized it first and used the experiment only to double-check that the balls behaved as he predicted. The answer is neither and both: without an experiment the law remains in the realm of theory, but an experiment alone can only generate data, not the law itself. What Galileo's experiment accomplished, as shown by Stengers, was to *stage* the proof by finding an action in the world – rolling balls down inclined surfaces – that is simplified enough to correspond to the equations that model how such balls behave. But this, Latour pointed out, involves focusing only on the time it takes the balls to roll down certain heights, while ignoring other elements such as the effects of friction, which do not apply to planets and stars in the vacuum of space.

We also decided to experiment on the nature of the *Laboratorium* catalogue. A difficulty with such publications is often that they are planned and executed before the opening of the

exhibition, which means they can't incorporate results unanticipated during a show's conceptualization stage. For *Laboratorium*, we designed a book machine: a publishing process that would run concurrently with the exhibition itself. We invited the designer and artist Bruce Mau to work at our headquarters at the Antwerp Museum of Photography for the show's duration. Each day, he would take the content that had been produced that day in conjunction with the show, from sites around the city. He would lay this content out as one would for a publication, creating new pages each day for an enormous, constantly expanding catalogue. Visitors themselves could enter into the process. By the exhibition's end, Mau had laid out about 300 spreads, 6,000 images and 18,500 characters of text. A copy of this giant archive, which spatialized the experience of the book machine, was then deposited in Antwerp's main library as a master record of *Laboratorium*. The archive was too unwieldy to enter the book market, of course, so we subsequently edited these pages into a smaller version (which still clocked in at nearly 500 pages) that could be distributed more widely.

Perhaps the most personal expansion of this exhibition space was undertaken by the artist Jan Fabre. He installed a tent and his childhood record collection in his own parents' garden, the location of which visitors could find on maps. In the midst of their searching the city for aspects of *Laboratorium*, they came upon one of the most important, and easily forgotten, sources of inspiration: the enclosure of a childhood home, which so often acts as the controlled environment where the earliest, most dreamlike experiments are conducted.

Science, as shown in *Laboratorium*, is not only about the generation of certainty and positive knowledge. It depends for its very impetus on the equally enabling, and opposite, state: doubt. Carsten Höller, an artist trained as a scientist, elaborated

a project that highlighted this feeling. His *Laboratory of Doubt* was an attempt to take account of the fact that, in a culture of highly advanced scientific knowledge, the general condition of doubt and perplexity felt by most citizens has not been reduced. In Höller's view, however, perplexity is not a negative condition, but an enabling one. He relates this to the paradox that as people in modern societies achieve high levels of material comfort, while not necessarily becoming happier than others, the 'maxim of well-being' is called into question. Rather than present answers in the form of what he called 'unassailable knowledge', Höller decided to present perplexity directly. The idea, as he said when I interviewed him about the project, was 'to give expression to perplexity, but it doesn't need to lead to anything. The idea was to confront the public in a state of perplexity so that the form may be found in the course of an exhibition, even if that means sitting on a bench and being perplexed.'

Höller used money from the exhibition budget to buy an old car, a Mercedes station wagon. He had the car covered with stickers that read 'The Laboratory of Doubt' in different languages. With a loudspeaker fitted to its roof, he then drove through Antwerp expressing his doubts. The car became a vehicle for rumour; as an artwork it both spread rumour and expressions of doubt via the megaphone, and it functioned as a story that people passed on to each other. Höller was always interested in how artworks can be carried by rumours. They become part of what Italo Calvino calls 'the invisible city', and I think *Laboratory of Doubt* worked this way.

An axiom: an exhibition is not an illustration. That is, it does not, ideally, represent the thing it purports to be 'about', in the way that a science museum will sometimes show a simplified version of an important discovery or result. Exhibitions, I believe,

can and should go beyond simple illustration or representation. They can *produce reality themselves*. *Laboratorium* was an attempt to put this into practice. Rather than invite scientists to summarize results or artists to bring along works, it sought to explore processes of creation, and the ground in which these practices are rooted. One of these grounds, is, of course, spatial. The scientist's laboratory and the artist's studio are formally distinct spaces in which certain kinds of activities are performed. But they are also historically and socially constructed: they are equally products of a particular time period. This was an exhibition where one had experiences, and therefore, made mistakes. One often finds oneself in exhibition formats that are a bit too fixed, lacking innovation in either a spatial or temporal dimension. As such, one must ceaselessly question these conventions and change the rules of the game.

Curating the Future

In 1968, Stewart Brand published the first *Whole Earth Catalog*, a countercultural DIY compendium selling useful products and disseminating information to anyone interested in creating new ways of life. A curatorial figure himself, who has organized conferences and created exhibitions, Brand recognized very early on that personal computers held the possibility for great social renovation – an intuition that came to him in 1962, he told me, when he witnessed Stanford computer scientists playing Spacewar, one of the first video games. Brand saw computing as another form of 'access to tools', as he described his famous catalog. Recently he told me that he believes curating has 'been democratized by the net, so, in one sense, everybody is curating. If you're writing a blog, it's curating. So we're becoming editors and curators, and those two are blending online.'

In the field of exhibitions, however, the potential of digital life is only just beginning to be explored – Paola Antonelli recently curated one of the first large-scale shows online, for MoMA, and websites like e-flux have begun to explore the communicative possibilities of the global digital network. But a new generation of younger individuals is beginning to contribute to contemporary art and culture. Born in the age of digitization, this group, referred to by novelist Douglas Coupland as 'the Diamond Generation', shares an irreverence for traditional

notions of authorship and cultural heritage, something that is manifested in their work. They have instant knowledge and technological know-how at their fingertips, and they rely on digital social platforms to showcase their new ideas and culturally iconoclastic approaches. The celebrated young artist Ryan Trecartin was quoted as saying: 'People born in the '90s are amazing . . . I can't wait until they all start to make art.' The creative climate of 2014 validates Trecartin's enthusiasm, as this new generation starts to enter the stage with a fresh set of radical and compelling artistic positions.

The year 1989 was marked by several paradigm-shifting events: while the collapse of the Berlin Wall heralded the beginning of the post-Cold War period, Tiananmen Square became marred by student protest and mass bloodshed. The Russian army left Afghanistan after a nine-year occupation, and the first Global Positioning System (GPS) satellite started orbiting the earth. Perhaps most significantly, Tim Berners-Lee wrote a proposal in which he outlined his idea for what would soon become the World Wide Web. We are now seeing the beginning stages of the maturation of the first generation who never experienced a world before these historic developments. Could there be some connection between such seminal global events and the creative production of these young artists, writers, activists, architects, filmmakers, scientists and entrepreneurs?

Together with the curator Simon Castets, I have begun an investigation charting the work of those born in or after 1989. *89plus*, as we call the project, is a form of international research that follows the development of this generational shift through various platforms, including conferences, books, periodicals and exhibitions. The introduction to our global study were presented in an eight-person panel at a conference in Munich in January 2013. Since then, continuous research, recommendations from

all over the world and an ongoing open call have shed light on the growth of a young, globally connected network of peers, which can be followed on an *89plus* website through an evolving set of network visualizations. *89plus* is an attempt to discover, assist and, ideally, empower a generation as they cross borders and foster a worldwide community of ideas. The aim is to provide an opportunity for young people from virtually all parts of the globe to have their ideas heard, showcased and implemented on the world stage.

The economist John Kenneth Galbraith once wrote that 'change comes not from men and women changing their minds, but from the change from one generation to the next'. Is this true? How can we track this kind of change? Can we, in addition, help a new generation take advantage of their special historic circumstances? These are the questions that our *89plus* project investigates, while bringing together individuals whose places of origin are as different as their practices, and whose voices are only starting to be heard. In this sense, the project presents a unique opportunity to understand how a younger generation's discourse is instituted through the networks they build.

In October 2013 we brought this network to Zaha Hadid's just-opened Serpentine Sackler Gallery in London, and held an *89plus* marathon of talks, lectures, presentations, interviews and performances. It consisted of those born in or after 1989, the year of the fall of the Berlin Wall and the first inklings of the World Wide Web. We are already starting to witness visionary acts of digital curating, and curating will surely change as a generation native to digital tools begins to develop new formats. This generation has grown up in an entirely new world. Perhaps by learning from them, we can learn something about our future.

Notes

1 *Caribbean Discourse: Selected Essays* (1989 and 1992).

2 In the late 1990s this collaborative spirit resulted in the formation of an association of curators, The Union of the Imaginary, to which I belong. Its official goals are 'to promote discussion and collaboration among curators; to develop a progressive understanding of the role of curatorial practice; and to fight homogenization and instrumentalization at every level of culture'.

3 See also the detailed description of different techniques in Markus Heinzelmann, 'Verwischungen. Die übermalten Fotografien von Gerhard Richter als Objekte der Betrachtung', in exh. cat. *Gerhard Richter. Übermalte Fotografien*, ed. by idem, Museum Morsbroich, Leverkusen et al. (Ostfildern: Hatje Cantz 2008), pp. 80–88, here pp. 84ff.

4 As famously quoted by Mario Merz.

5 I had met Gordon in 1991. He was part of a younger generation of artists with a new spirit of collaboration. At our first meeting he told me, with characteristic boldness, that the 1990s would be a decade of promiscuous collaboration. This turned out to be completely true. Gordon also helped to change my understanding of cities. I was invited to give a lecture in his home town of Glasgow by the 'Transmission' artist space. On that trip I realized that Glasgow was as important for art as any big city.

During the 1990s, as the contemporary art world expanded, art was being produced in many more places.

6 An example would be his 'Stacks objects', piles of offset prints that visitors are welcome to take home. Gonzalez-Torres redefined the social contract between artist and museum visitor, in effect substituting generosity for tight control. It's hard to think of a better metaphor for a new inclusivity, a welcoming of the public, than this. Whether he marks out spaces with garlands of light or sets out his unstable 'Stacks' to vanish or decorates spaces with posters, Gonzalez-Torres' works always provide the beholder with opportunities for real action. With a conscious proximity to conceptual and minimal conventions, he creates deviations of form that continue to put the beholder / object rapport to the test. Gonzalez-Torres starts from what is nearby in order to see what is already there in another way. His influence on the succeeding generation is impossible to overstate.

7 These have recently been collected by Luc Santé in the book *Novels in Three Lines* (2007).

8 I met many people who came by, and that was the beginning of this ongoing conversation which remains one of the most active aspects of my working method. Like the kitchen show, it was very private and clandestine for the first two weeks. During the first few weeks of the show, the porter, having no idea what was occurring upstairs, would announce visitors over the hotel telephone like this: 'You have a "client" here.' But unlike my kitchen show, which took place in the small town of St Gallen in Switzerland, this was Paris, and from the third week on, the intimacy gradually disappeared. By the show's last day, *Libération* and *Le Figaro* had reviewed it, and there were people lined up in the street to get in. The artworks from the exhibition were reproduced as postcards and put in a printed yellow slip case / box alongside an exhibition brochure.

9 In 1843, as Christmas was becoming the dominant holiday in Victorian London, Cole even published and sold the first commercial Christmas card under the Summerly name, as Elizabeth Bonython and Anthony Burton point out in their biography *The Great Exhibitor: The Life and Work of Henry Cole*. 'Felix Summerly' did not stop at writing, however: in 1846 he submitted under the Summerly name a design for a tea set that won a competition sponsored by the Society for the Encouragement of Arts, Manufactures and Commerce.

10 *When Attitudes Become Form* was influential enough that the show was restaged in Venice in 2013 as *When Attitudes Become Form: Bern 1969/Venice 2013* by curator Germano Celant in dialogue with Thomas Demand and Rem Koolhaas.

11 For a long time Parreno's ideas formed an inspirational agenda, but putting on an exhibition that would work along the lines he suggested remained unrealized. It could have happened in lots of different contexts, but we couldn't find an opera, a theatre or museum willing to host such a project. It seems that there remains a lack of institutions for such grand interdisciplinary endeavours. In 2007, however, the Manchester International Festival was founded. This biennial festival's goal is to bring together music, opera, theatre and the visual arts, very much in the spirit of Sergei Diaghilev. Its founding director, Alex Poots, invited me to realize our hitherto unrealized project.

12 'I always felt,' Barney said, 'that in the middle of the *Cremaster* cycle, that there were situations, if they could be witnessed by an audience, that were nearly perfect situations, but what made them that way was the failure . . .'

13 The full list includes pavilions by Hadid (2000), Daniel Libeskind (2001), Toyo Ito (2002), Oscar Niemeyer (2003), Alvaro Siza and Eduardo Souto de Moura (2005), Rem Koolhaas with Cecil Balmond and Arup (2006), Hadid and Patrik Schumacher (2007),

Olafur Eliasson and Cecil Balmond and Kjetil Thorsen (2007), Frank Gehry (2008), SANAA (2009), Jean Nouvel (2010), Peter Zumthor (2011), Ai Weiwei and Herzog & de Meuron (2012) and Sou Fujimoto (2013).

14 I've often thought about the impossibility of producing a portrait of a city with Stefano Boeri; when we did 'Mutations' in Bordeaux we were concerned that it is impossible to produce a synthetic image of a city, because the city is so complex. As the late Oskar Kokoschka pointed out, when he was making a city portrait, that the city has already changed by the time the painting is done, so how can you do a synthetic image of the city? The idea of an interview Marathon was also, then, the idea of a knowingly partial portrait – people are cities, cities are people, and then through all these practitioners you get an idea of the score of the city. Some come at night, some come during the day, some stay the whole Marathon, and then we found out after the Marathon in Stuttgart that lots of dinners had been triggered – which of course I wasn't part of because I was sitting there – but a lot of people went off at two in the morning and said, Let's go and eat, what is still open? So there were all these people meeting each other after the Marathon at the only restaurant which was open. And so it's almost like you build a community, because the visitors come to know each other and are not just consuming a lecture and going home.

15 The list of speakers: Marina Abramović, Oladele Ajiboye Bamgboye, Stefano Boeri, John Casti, Gregory Chaitin, Chang Yung-Ho, Olafur Eliasson, Cerith Wyn Evans, Evelyn Fox Keller, Carsten Höller, Hsia Chu-Joe, Ikegami Takashi, Rem Koolhaas, Sanford Kwinter, Mark Leonard, William Lim, Sarat Maharaj, Miyake Akiko, Mogi Ken'ichiro, Hans Ulrich Obrist, Israel Rosenfield, Saskia Sassen, Luc Steels, Wang Jianwei, Anton Zeilinger.

16 Many laboratories are physically situated in a particular building, but we decided it was important not to limit an exhibition to just those. As Latour wrote, 'The very distinction between the inside of the laboratory and the outside, be it nature or society, is not so easy to trace anymore' (from *Laboratorium*). Many are also invisible, forming part of the invisible city. Artists, social scientists and natural scientists have often thought of a city's space as the 'field', while a controlled interior setting is the 'studio' or 'laboratory'. But often the practices in which they engage are not so distinguishable by the location in which they occur. This is an insight I first gleaned from Kasper König, who believed the museum should be used as a relay that both concentrates activity and sends it out into the world.

Laboratory science depends hugely for its effectiveness on which aspects of a situation are considered relevant and which are not. As Latour later wrote: 'Exactly the same divide between primary and secondary qualities exists in the very trope of artistic iconoclasm: "il faut épater le bourgeois!" What Philistines believe to be good taste is immaterial for a modern artist exactly as, for a neurologist, your idea of how your brain functions is of no interest whatsoever in mapping out electrochemical pathways.' Latour is pointing out a hidden similarity between contemporary artistic and scientific practices, in which the important task is to discover which phenomena, amongst the noise and static of the world, warrant attention. According to Latour, by looking at the difficulties inherent in making these choices, for scientists and for artists the exhibition performed a meta-experiment on the different fields themselves. And interestingly, since *Laboratorium*, Latour has continued to curate exhibitions, as an adjacent practice to his research and scholarly writing.

Responding to the exhibition's desire to hybridize positions and fields, Xavier Le Roy presented a choreographed work called *Product of Circumstances*. In it he blurred the lines between biography and theory, and between the lecture and performance. Presented in a theatre, Le Roy created a situation that eroded the usual separation of audience and performer. He kept lighting conditions equal on either side of the divide. He spoke about his history as a trained molecular biologist while also training in dance and playing basketball – for Le Roy, the body and mind are not Cartesian opposites, but elements in the gestalt of every human being. He presented slides from his biological research on the genes related to breast cancer, then segued into a performance of part of a dance piece called 'Things I Hate to Admit'. The interplay between these two formats accepts the importance of both, while opening up an in-between space in which each, and their interconnections, can be explored. At another point, he sat on the floor of the stage, motionless and silent, for a minute.

Continuing to speak about his scientific research, Le Roy mentioned the choreographer Yvonne Rainer's film *MURDER and murder* (1996) – a film that ironically speculates on breast cancer and its relation to sexuality. The lines between these different ways of thinking about the body merged in a new way. After this, Le Roy again broke off the lecture and performed an excerpt from another choreographed piece, before continuing to speak. He described the indistinct conditions his practice began to evoke: 'my point of view within society changed, and I found myself in a blurred field of similarities between the social and political organizations of science and dance. I felt like a fugitive who actually never escaped what he thought he was.' He then demonstrated sections of pieces by Rainer that he re-

created in 1996. In a statement that perhaps summarizes many of *Laboratorium*'s concerns, Le Roy finished by saying, 'I would like to suggest that this performance was about a contaminated body in its weavings of historical, social, cultural, and biological levels, being the place and time for a path of different thoughts unable to transform themselves into abstraction and theory.'

The historian of science Peter Galison examined the development of early twentieth-century physics. He explained the scientific importance of image producers, inaugurated by Charles Wilson's creation of the cloud chamber in 1895, an instrument that made it possible to image, for the first time, the previously invisible scattering of charged alpha particles. Galison also discussed an opposing tradition – that of electronic counters, committed to 'anti-visual ways of approaching the microphysical world' and utilizing logical inference and statistical data rather than direct observation. These traditions were eventually combined in the electronic imaging technologies that attended the new detectors of the 1970s, in which particles were smashed into one another and which required the building of vastly larger detector systems.

The unification of these two traditions was neither seamless nor immediate, Galison explained: 'only bit by bit, literally, did they begin to form a common language, a way of speaking, and a common set of practices that would allow them to combine their ways of analysing data. Not a Gestalt change, but a hard-fought, step-by-step construction of an intermediate zone of exchange.' What can be learned from this? 'If one needs a slogan, it might be this: the solution of local problems demands a local language, a language both in a verbal and in a non-verbal sense.' Galison's final summary could have stood in for the entire exhibition's own discovered position: 'the laboratory is

always an assembly of divergent parts, tied together with fragile, partial traditions. Words, rules, things – always under conflicting pressures, always bound together in pieces . . . We use the laboratory to search for means to bind, split and recombine the myriad partial subcultures of the world around us.'

Acknowledgements

My very special thanks to Asad Raza, who exuded great wisdom, enthusiasm, patience and friendship in producing *Ways of Curating*. Foremost thanks are due to the artists whom I have worked with, spoken to and been inspired by throughout my life. They are the reason for my activity. I would also like to thank Carlos Basualdo, Klaus Biesenbach, Daniel Birnbaum, Stefano Boeri, Francesco Bonami, John Brockman, Simon Castets, Bice Curiger, Steffi Czerny, Okwui Enwezor, Kate Fowle, Hou Hanru, Dorothea von Hantelmann, Jens Hoffmann, Maja Hoffmann, Koo Jeong-A, Sam Keller, Kasper König, Walther König, Rem Koolhaas, Bettina Korek, Gunnar Kvaran, Karen Marta, Kevin McGarry, Isabela Mora, Ella Obrist, Suzanne Pagé, Philippe Parreno, Julia Peyton-Jones, Alex Poots, Alice Rawsthorn, Beatrix Ruf, Anri Sala, Tino Sehgal, Nancy Spector, Rirkrit Tiravanija, Lorraine Two and Dasha Zhukova. In addition, I would like to thank the book's editor, the excellent and unreasonably patient Helen Conford; the book's agent, the steadfast Kevin Conroy Scott; its copy-editor, Richard Mason; and Charles Arsène-Henry, who initiated the project. For research help, many thanks go to Natalie Baker, Laura Boyd-Clowes, Chloe Capewell, Patricia Lennox-Boyd, Roberta Marcaccio and Max Shackleton. In *Ways of Worldmaking*, Nelson Goodman wrote that art and science are both of utmost importance to understanding our multiplicity of worlds; this book's title was inspired by his.